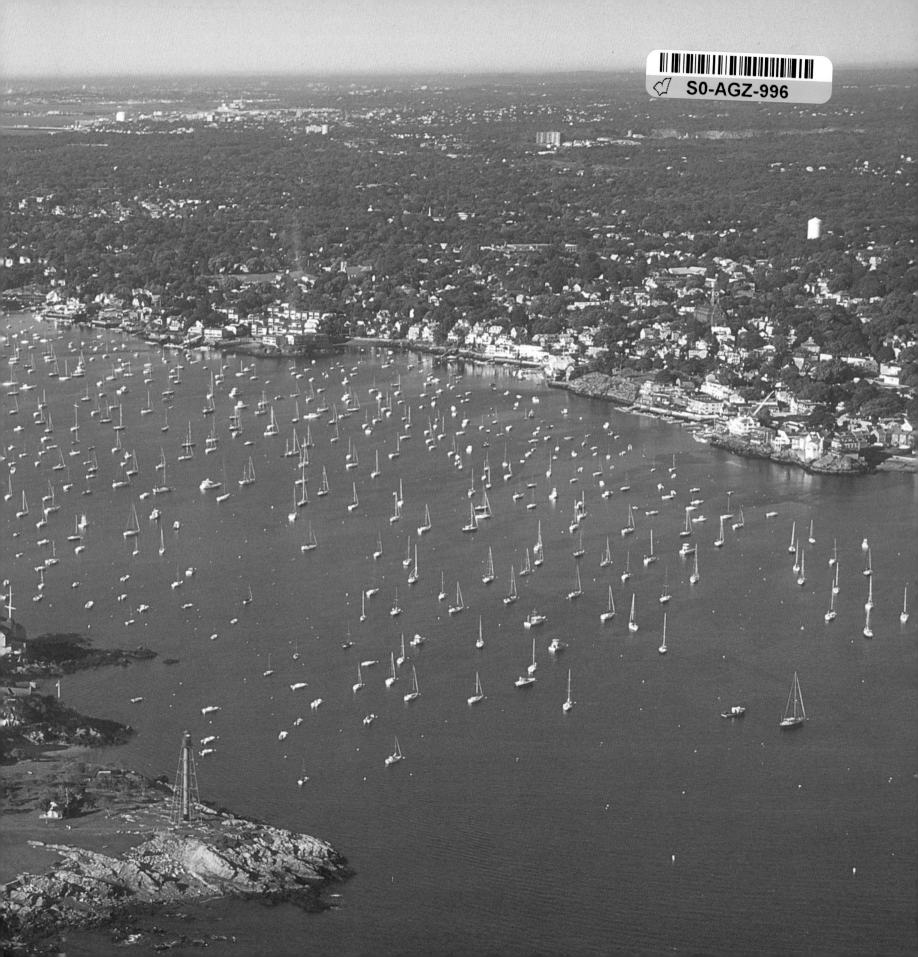

Marblehead

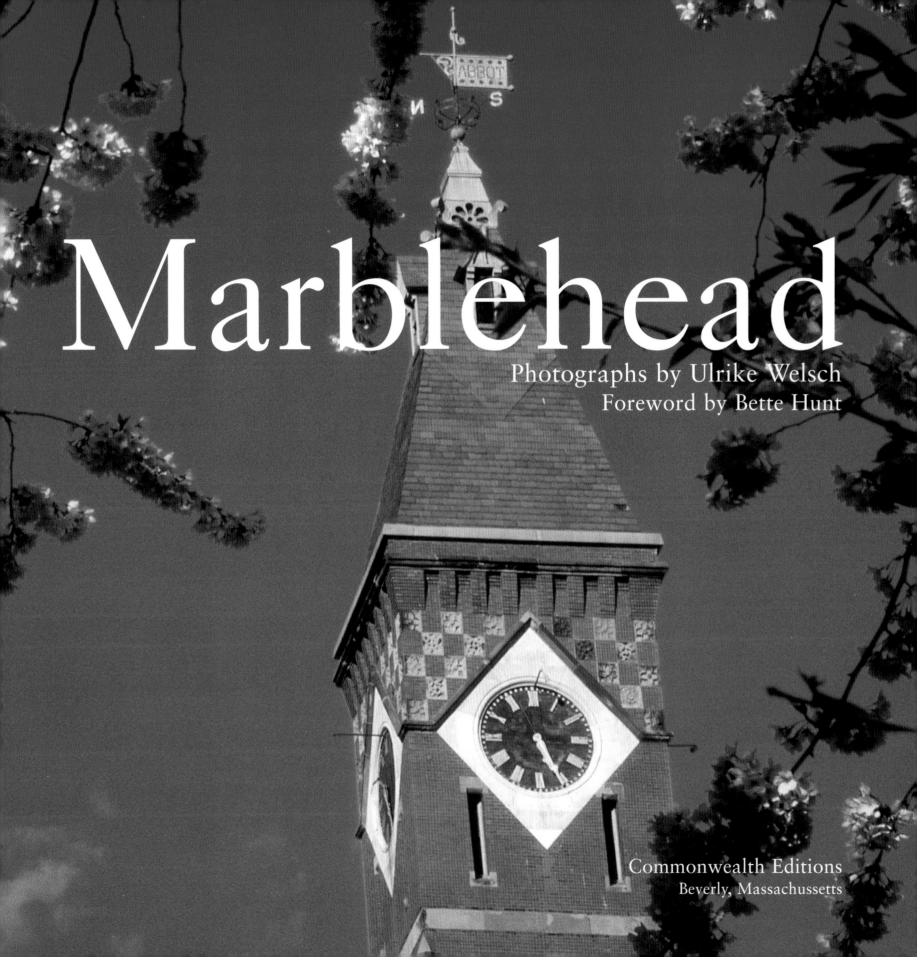

Marblehead

Photographs by Ulrike Welsch
Foreword by Bette Hunt

Commonwealth Editions
Beverly, Massachussetts

DEDICATION

I dedicate this book in loving memory of my most precious parents, my "Mutti" and my "Vati." To this day, I admire the composition of my father's photographs from the 1940s and the humor and feel for aesthetics that my mother radiated. From them I learned the rewards of discipline and the advantage of possessing a keen awareness. I am grateful that they introduced me to the wonders and beauty of nature and taught me to have an appreciation for the little things in life.

Cover and interior design by Jill A Feron.
Printed in South Korea.

Published by Commonwealth Editions,
an imprint of Memoirs Unlimited, Inc.,
21 Lothrop Street, Beverly, Massachusetts 01915.

Visit our web site: www.commonwealtheditions.com.

To appreciate the full range of Ulrike Welsch's work,
visit www.ulrikewelschphotos.com.

CONTENTS

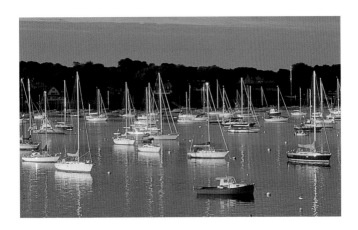

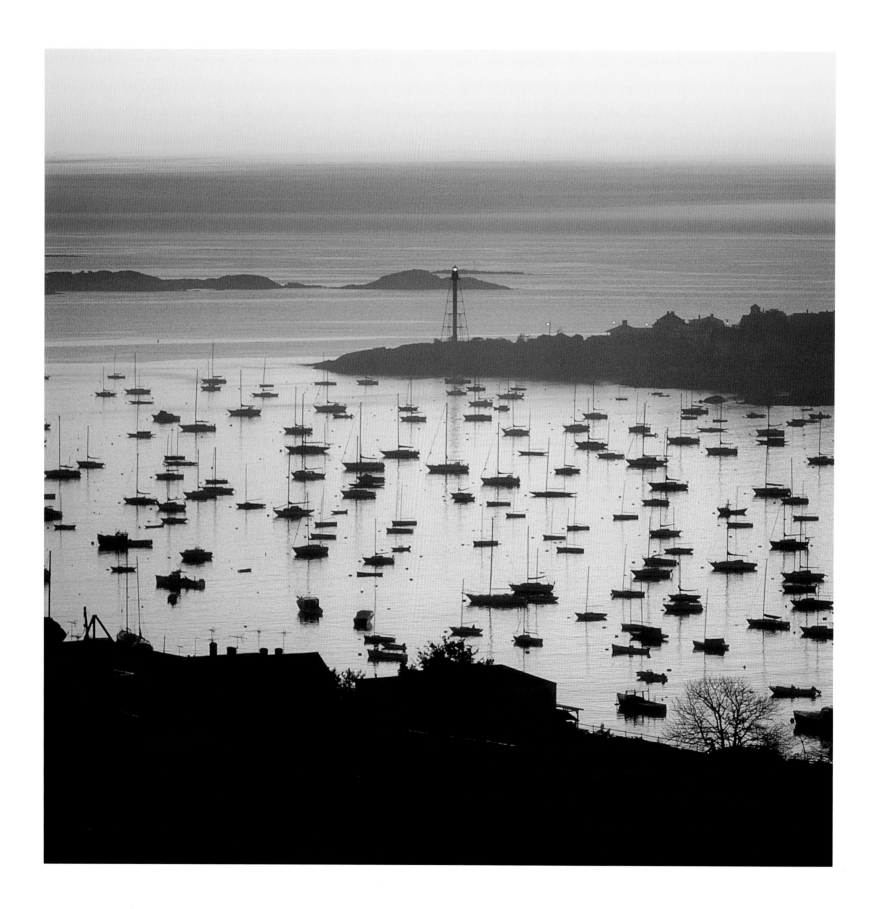

FOREWORD

Marblehead is a peninsula with an island appendage located on Massachusetts Bay about halfway between Boston and Gloucester. It's small, measuring just over four square miles, with a population that hovers around twenty thousand. Since the town is virtually surrounded by water and blessed, thanks to a long-receded glacier, with a deepwater harbor, Marblehead's focus has always been the sea.

It was the promise of a bountiful sea that drew Marblehead's first settlers. In 1629 a group of hardy fishermen from the Channel Islands and the west of England arrived and were soon joined by a mix of religious dissidents, one or two university graduates, and a sprinkling of entrepreneurs. Despite rough weather, hardships, and loneliness, the settlement took hold, and before long headlands were covered with racks of fish being cured for shipment abroad. Marblehead's semi-isolation fostered a strong sense of independence and self-reliance among its inhabitants, and by 1649 it was incorporated with the form of government that prevails today: town meeting, a board of selectmen and other officials who are elected annually, and citizens' committees.

By the 1660s the town's reputation as a premier fishing station prompted a royal agent in London to declare that Marblehead was "the greatest Towne for fishing in New England." With each passing decade the town grew and prospered until, by the 1760s, it was the sixth-largest town in the Colonies, with five thousand inhabitants and fifty merchants engaged in foreign trade. The wealth resulting from fishing and onshore industry created a building boom. New houses appeared along the narrow, crooked streets, from simple half-houses for the less affluent to luxurious mansions for members of the "codfish aristocracy." Situated every which way, often with little or no land around them, these pre-Revolutionary wooden houses represent one of the largest concentrations of such buildings in America.

Marblehead totally committed itself to the Revolutionary War and the fight for independence. Marbleheaders answered General George Washington's call for vessels to attack British supply ships by arming boats and manning them to go to sea as "ye navy of the United Colonies." The nautical and fighting prowess of General John Glover's Marblehead regiment served Washington at the battle of Long Island and again at the battle of Trenton when it carried him and his unit across the Delaware River to win a decisive victory in December 1776.

By the end of the Revolution Marblehead had changed dramatically. Most of its male population were casualties of the war, the town's wealth was gone, and the fishing business was in shambles. The town was still rebuilding when the War of 1812 broke out and Marblehead's maritime skills were put to the test once again. It was no accident that many of the crew aboard the USS *Constitution* were Marbleheaders. When "Old Ironsides" was being chased by two British frigates on April 3, 1814, one of her Header crewmen, who knew the harbor's navigational hazards, took over the helm and brought the ship safely in under the guns of Fort Sewall. With no charts of submerged rocks or channels, and mindful of the fort at the harbor's mouth, the British were forced to give up the chase, allowing *Constitution* eventually to return to Boston unmolested.

Despite Marblehead's valiant attempts to recover following the War of 1812, its days as a premier fishing and trading port were over. A few vessels continued to sail to the Grand Banks, but a devastating gale in 1846 virtually wiped out the small fleet, and most of the town's fishermen turned to a secondary (and certainly less perilous) occupation that had long sustained them between fishing trips.

Early town records carry references to "cordwaining," the making of shoes. By the early 1800s this trade became widespread, offering employment particularly during the winter months when the fishing fleet stayed in port. Shoemakers crafted shoes in small buildings known as "ten-footers," sometimes alone, but more often working in the company of two or three others. After the 1846 Grand Banks gale, shoemaking became an important form of employment, and factories were built where both men and women worked on assembly lines. Many of the factories where located in an area near the middle of town, and in June 1877 a large number of these were destroyed by fire. Newer and bigger factories were built, and Marblehead competed with other leading shoe-manufacturing communities in Massachusetts. Just ten years later, however, the same area was once again consumed by fire and Marblehead's shoe industry was finished.

By the late nineteenth century Marblehead was becoming principally a residential community. The railroad brought visitors to town to enjoy "the healthful, joyous and inspiring influences of summer by the sea." Hotels and cottages sprang up in town and on

Marblehead Neck. As personal fortunes grew, impressive summer residences were built, and with its fine harbor, boatyards, craftsmen, and sailors, Marblehead became a yachting center. The harbor rapidly filled with pleasure craft—both beautiful yachts and smaller racing boats. Yacht clubs were formed, including the first junior yacht club in America. International regattas began, and soon the newspapers began to call Marblehead "the yachting capital of the world." Today the summer harbor is filled to capacity with moorings, and a very active sailing community keeps Marblehead's seafaring heritage alive.

Marblehead is infinitely more than a historical town by the ocean. It has always been defined as much by its nonconformity and independence as by its natural beauty and preoccupation with the sea. The town has survived for over 350 years, traditions intact. Few communities in the country have such respect for the deeds of their ancestors or such awareness of the town's place in history.

◆　◆　◆

Marblehead is very special to me. I love hearing, and repeating, the old stories that are so much a part of the town's fabric. Could there be another town with the peculiar nicknames unique to generations of Marbleheaders? And then there's the idiosyncratic language that allows a Marbleheader to identify a fellow Header instantly. Who but a Marbleheader would respond to the greeting "whip" or know that the only response to "Down Bucket!" is "Up for air!"?

In the early 1900s the town celebrated Old Home Week. The program of events included a list entitled "Marbleheaders No Longer Living in Town." No matter where a Header lives, or how long he or she has been away, once a Marbleheader, always a Marbleheader.

— Bette Hunt, Spring 2000

THE HISTORY

Granted its independence from Salem on December 12, 1648, Marblehead is a town rich in history and tradition, which Marbleheaders of all ages continue to honor 350 years later.

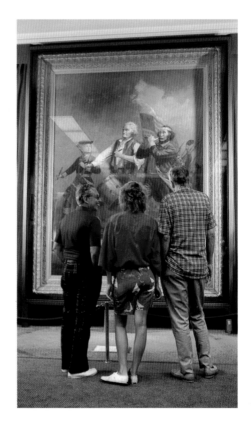

Inside Abbot Hall, in the selectmen's room, visitors view A. M. Willard's famous painting *The Spirit of '76*. Outside, a British regiment fires off a ceremonial salute on the Abbot Hall grounds during the town's 350th anniversary celebration.

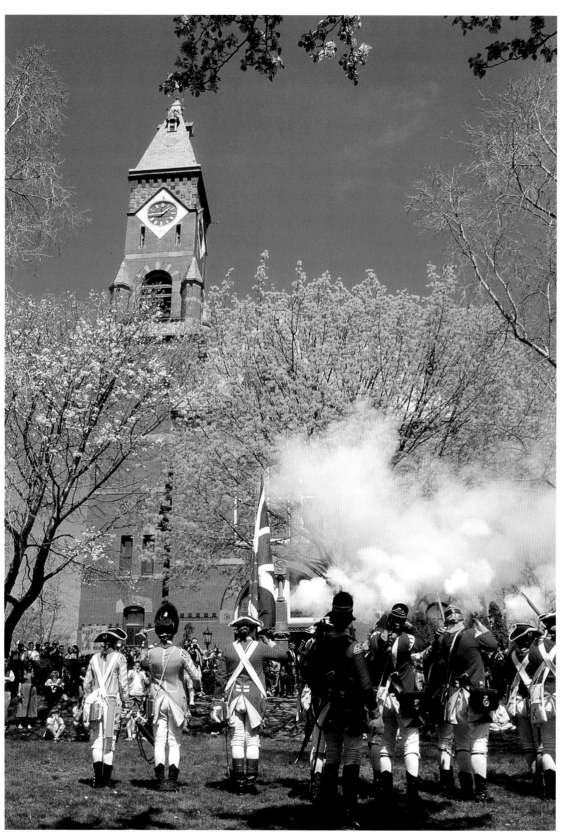

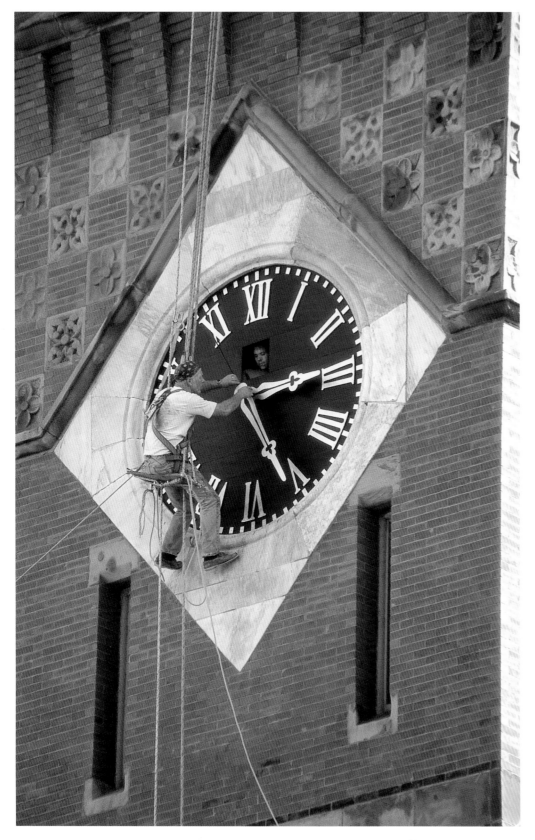

I ring at twelve the joyful rest at noon.

I ring at nine to slumber sweet of night.

I call to Free men with my loudest tones.

Come all ye men and vote the noblest right.

 —Legend on bell at Abbot Hall,
 donated by James J. H. Gregory

Workmen repair the Abbot Hall clock.

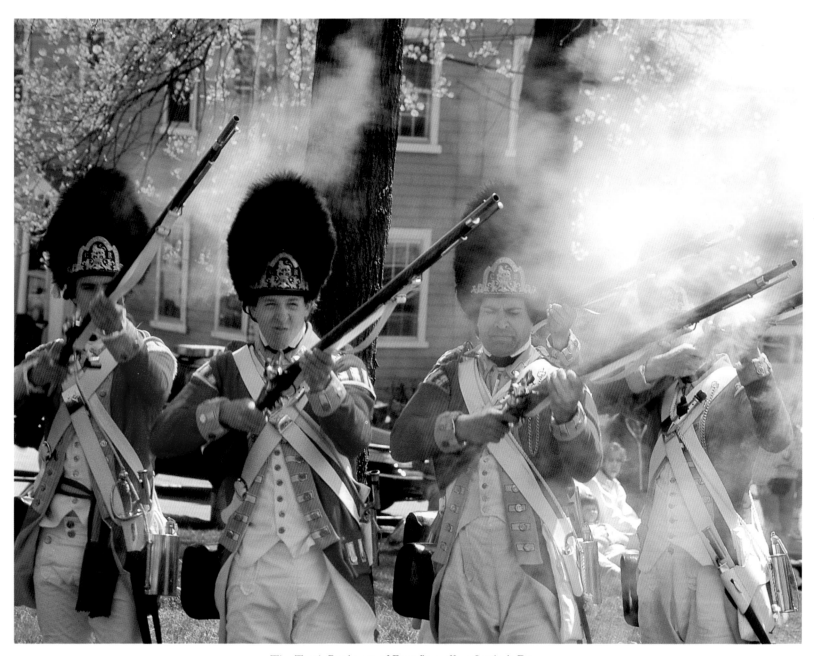

The Tenth Regiment of Foot fires off on Settler's Day.

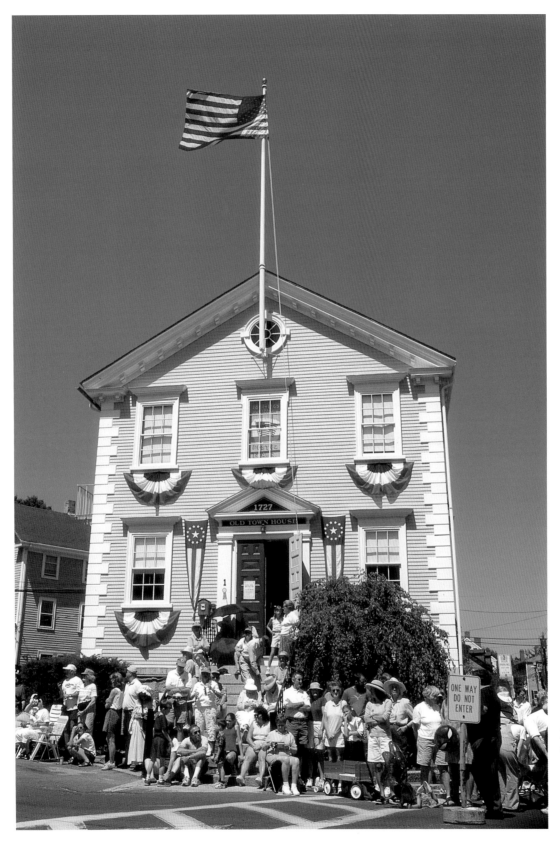

Marblehead's Old Town House, also known as its "Cradle of Liberty," was built in 1727 on the site of the old jail.

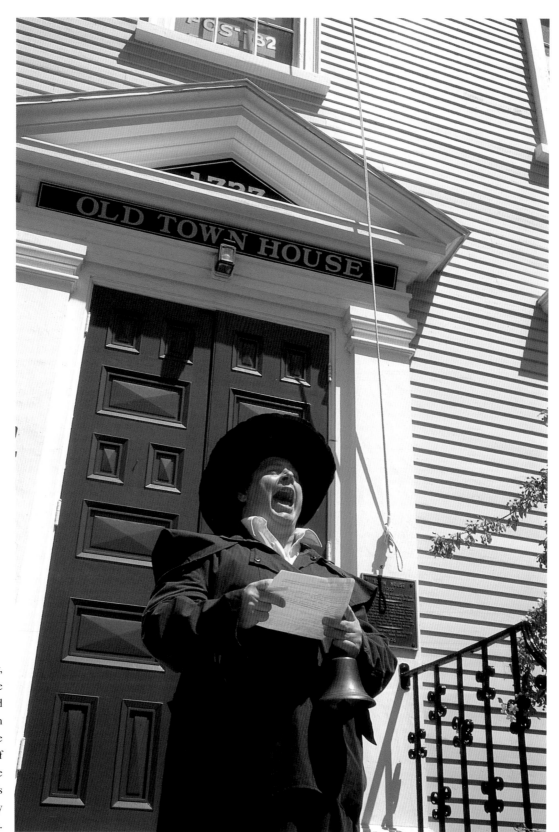

George Derringer, long-time writer for the *Marblehead Reporter* and modern-day town crier, recreates the announcement of America's independence during the town's 350th birthday celebration.

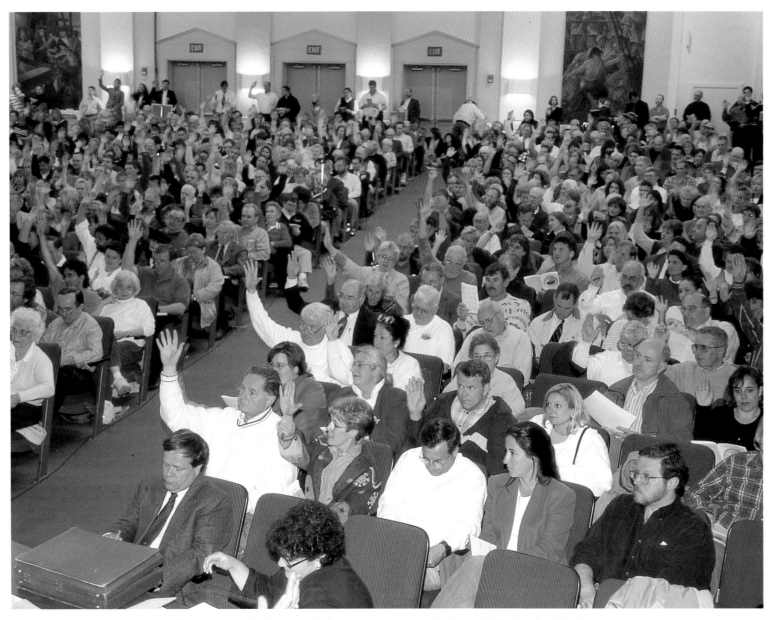

Heavy turnout is the norm during spring town meeting in the high school auditorium.
With only two brief interruptions, town meetings have governed Marblehead for 350 years.

*What the hell's the Commonwealth
of Massachusetts got to do with
Marblehead?!*

— Irate citizen at town meeting

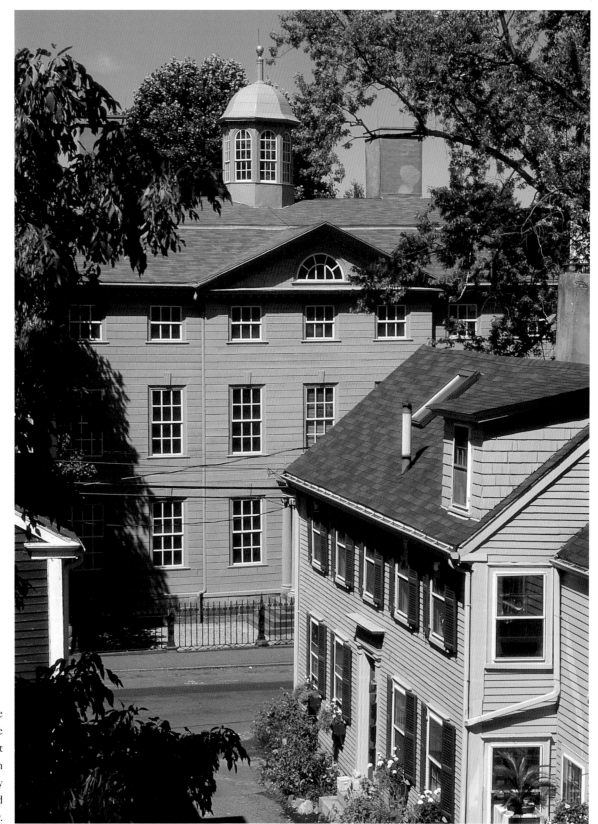

Built in 1768, the
Jeremiah Lee
Mansion at
161 Washington
Street is owned by
the Marblehead
Historical Society.

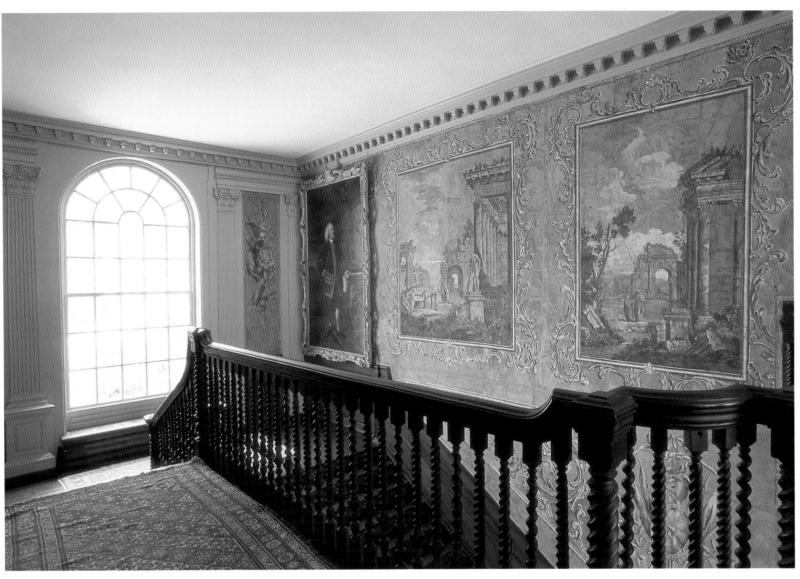

Original wallpaper, handpainted in scenic *grisaille* style, still graces the hallway of the Lee Mansion.

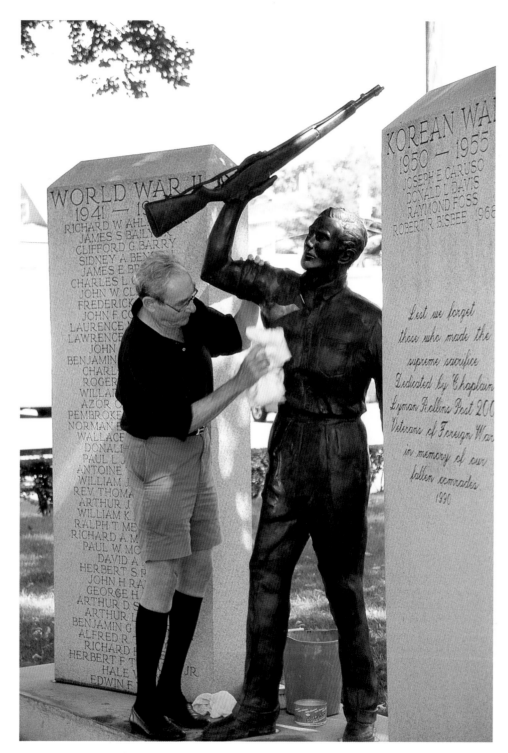

Sculptor Kenneth Herwitz polishes his work at the war
memorial in Memorial Park on Pleasant Street.

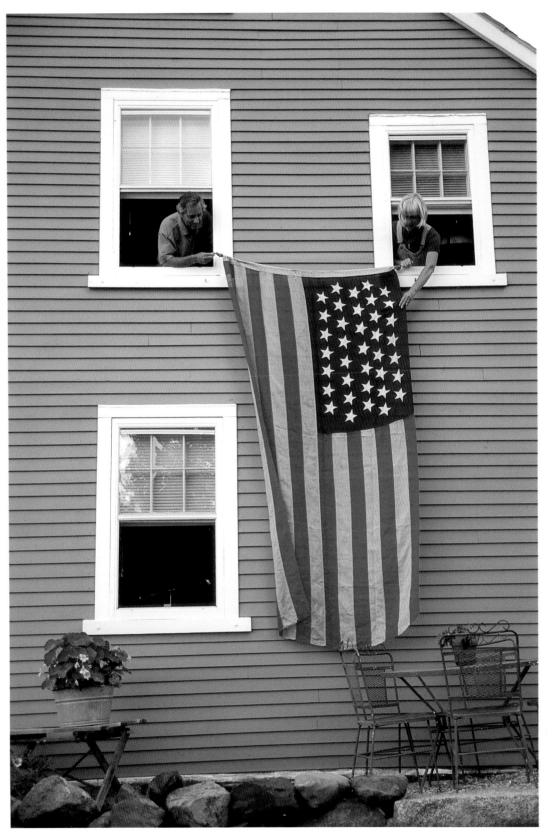

In preparation for Independence Day, Headers proudly display an all-wool American flag. With thirty-seven stars, it dates from the ten-year period following Nebraska's admission to statehood on July 4, 1867.

19

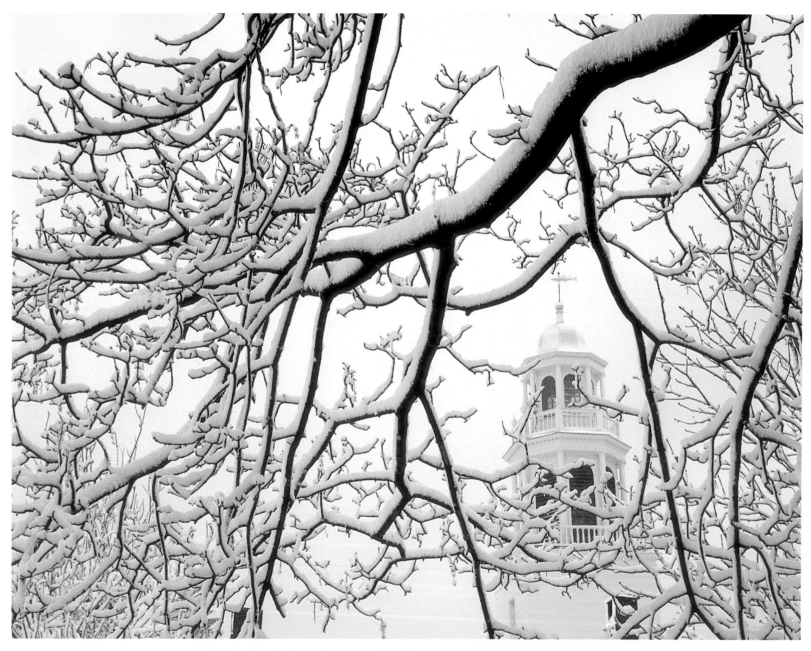

Winter boughs frame the tower of Old North Church and its cod weathervane.
Marblehead's first church, founded in 1635, was located on the site of Old Burial Hill.
Old North was built in 1824 after the town's second meetinghouse, located on Franklin
Street, was torn down.

For many years, local historian Harry Wilkinson (1908–1999) contributed a popular column, "Down Memory Lane," to the pages of the *Marblehead Reporter*.

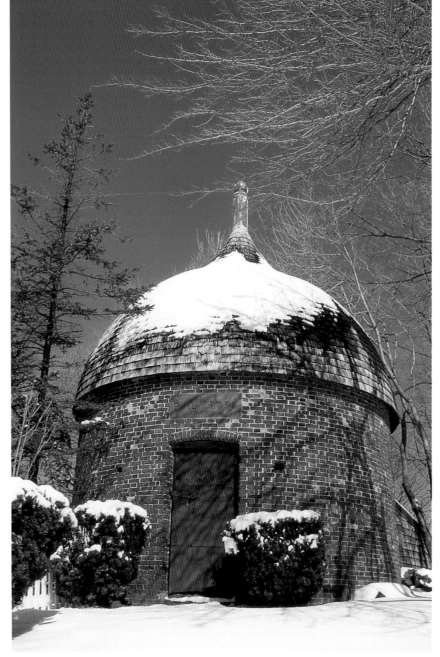

The circular Powder House at 37 Green Street, built in 1755, was used as a storehouse for muskets and ammunition during the French and Indian War, the Revolution, and the War of 1812. Each of the bricks is handmade.

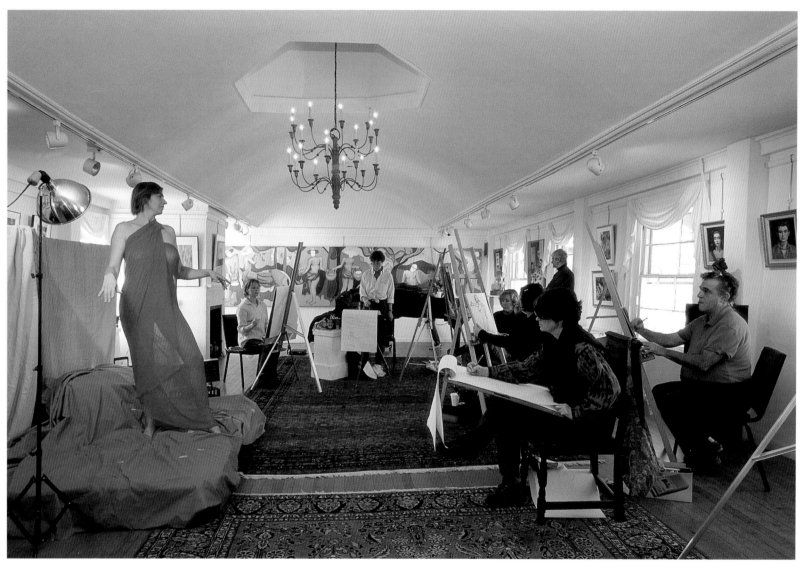

The grand ballroom in the King Hooper Mansion at 8 Hooper Street, once the site for
elaborate dinners and parties, now hosts life-arts classes, exhibitions, and concerts.

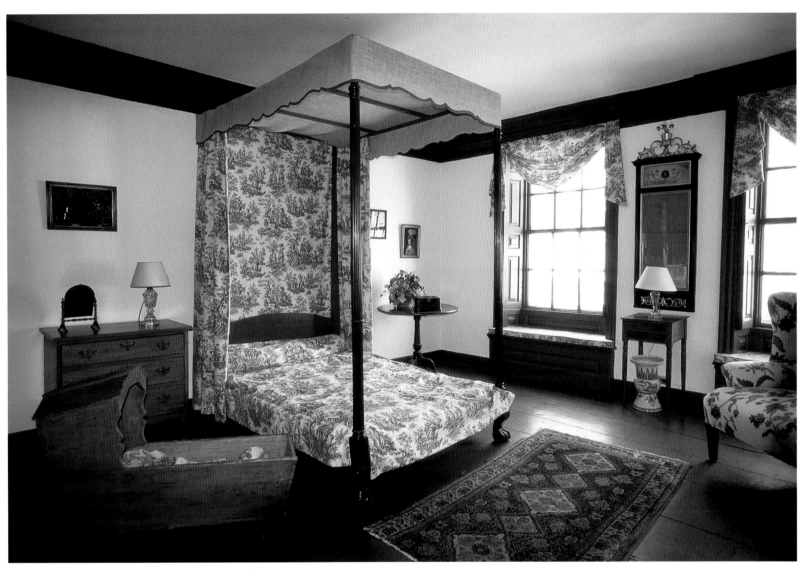

The Cabin Room in the Hooper Mansion. The eighteenth-century home of one of
Marblehead's wealthiest ship owners is now owned by the Marblehead Arts Association.

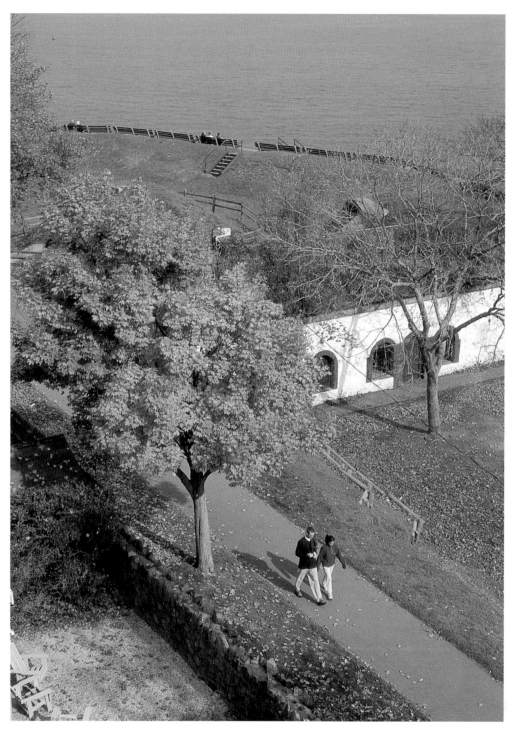

Fort Sewall in autumn, viewed from a widow's walk. Construction of the fort began in 1666. On April 3, 1814, its guns protected the USS *Constitution*, when the American vessel was chased into Marblehead Harbor by two larger British ships.

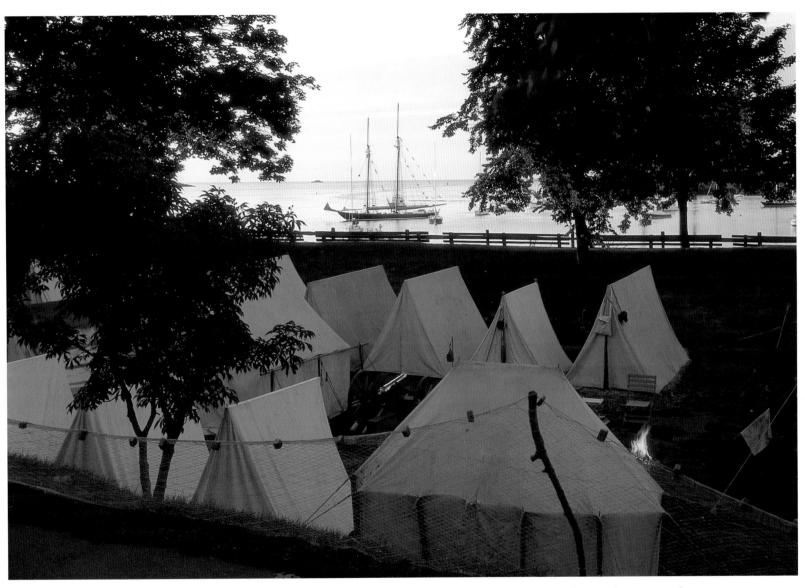

Every July, Glover's Marblehead Regiment camps at Fort Sewall. This group of reenactors honors the memory of General John Glover and the many Marbleheaders he led to victory in the Revolutionary War battles of Long Island and Trenton. It was one of Glover's men who rowed General George Washington across the Delaware, en route to Trenton.

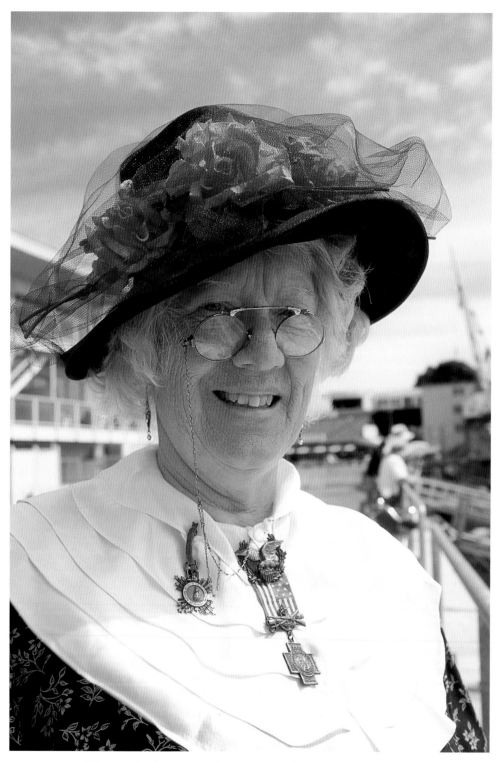

They say it takes at least five generations in town to make a true
Marbleheader. Karin Martin, dressed here for the town's 350th
anniversary celebration, can trace her Marblehead ancestry to the 1750s.

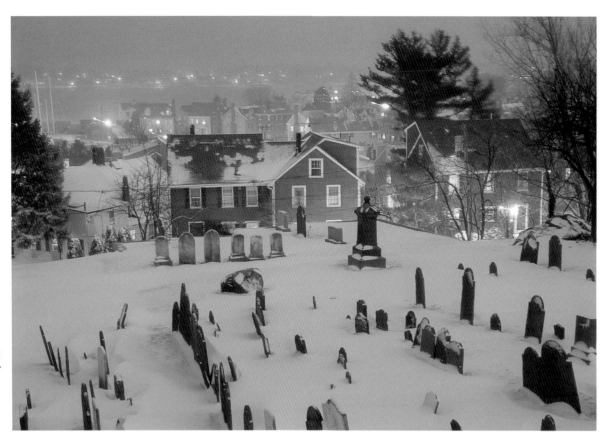

Old Burial Hill, off Orne Street, was the site of the town's first meeting house and is now the resting place of many early settlers, including General John Glover and over six hundred soldiers of the Revolutionary War.

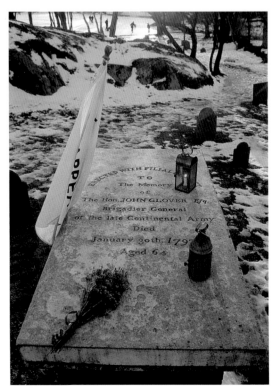

General John Glover is remembered by Marbleheaders each year on the date of his death, January 30, 1797.

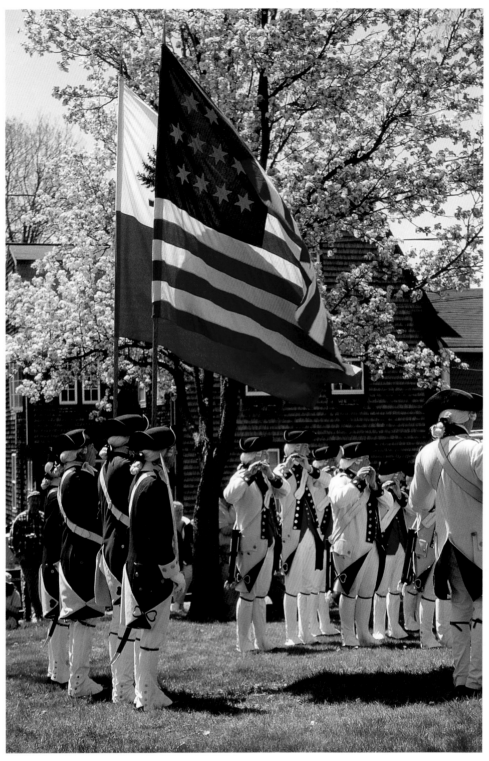

A Settler's Day parade musters on Trainingfield Hill beneath Abbot Hall.

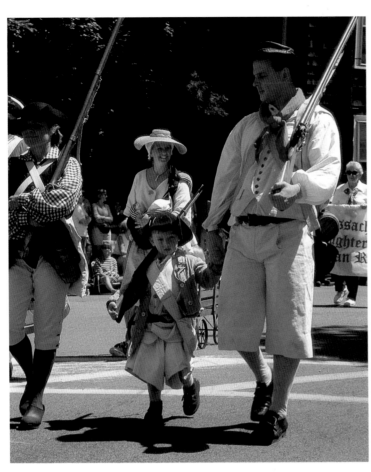

Glover's Regiment is a more diverse collection of Marbleheaders than in the General's day.

Few are the communities throughout the country with such reverence for the deeds of their ancestors or awareness of their town's place in history.

— Alexander MacDonald and Virginia C. Gamage, "Marblehead 1629–1979"

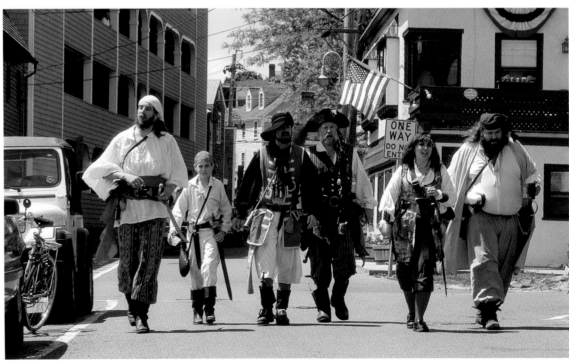

The Pirates, a group that entertains with old seafaring tales, strolls down Front Street.

THE WATERFRONT

Few towns so small have so much coast. Here on the waterfront, where ledge and surf collide, Marbleheaders of all stripes—from the first hardy fishermen to today's summer sailors—have derived a livelihood and much enjoyment.

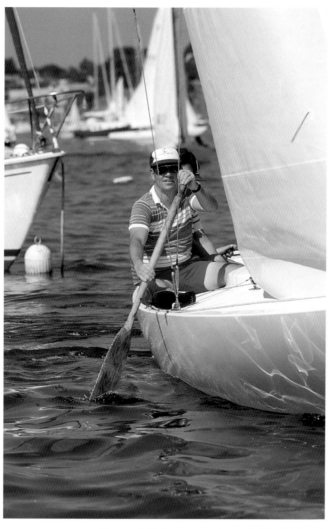

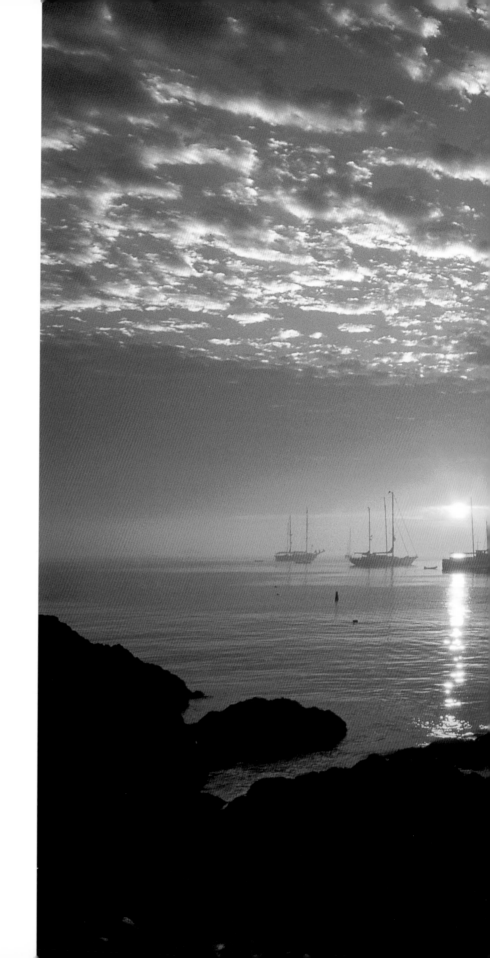

Boats of all sizes are welcome in Marblehead, from sailboats that may require oars on a windless summer's day to the fleet of the New York Yacht Club, moored at dawn at the harbor's mouth.

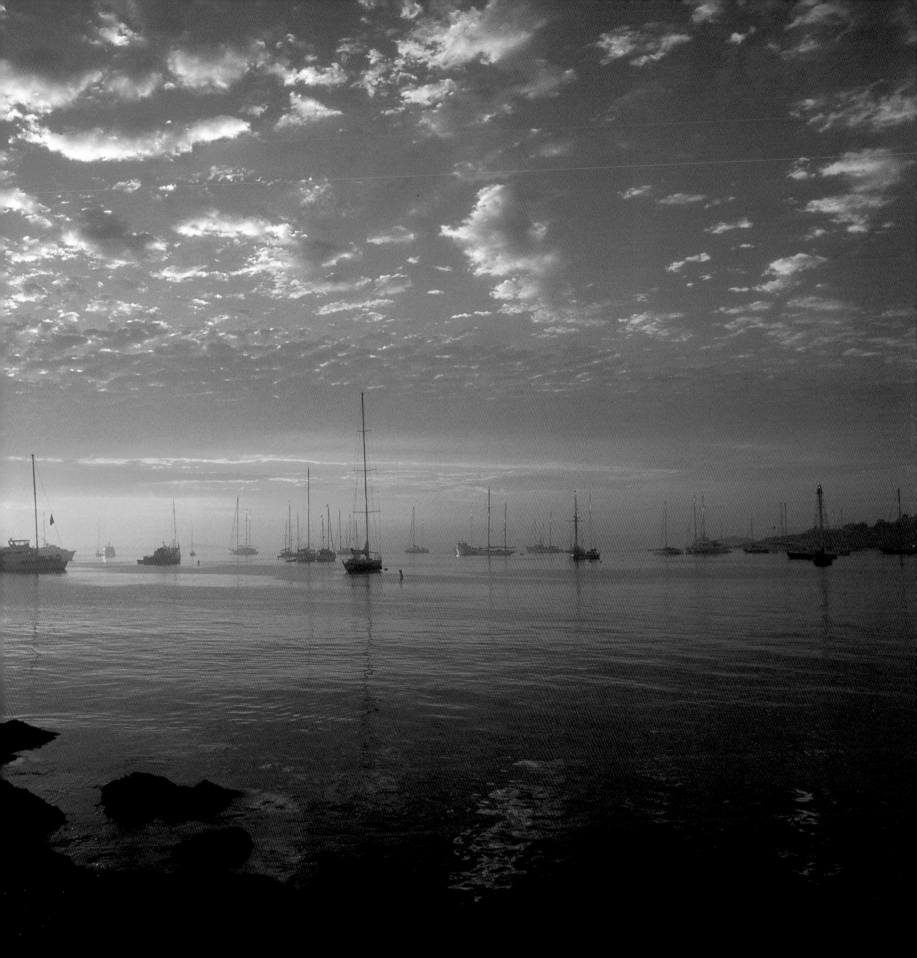

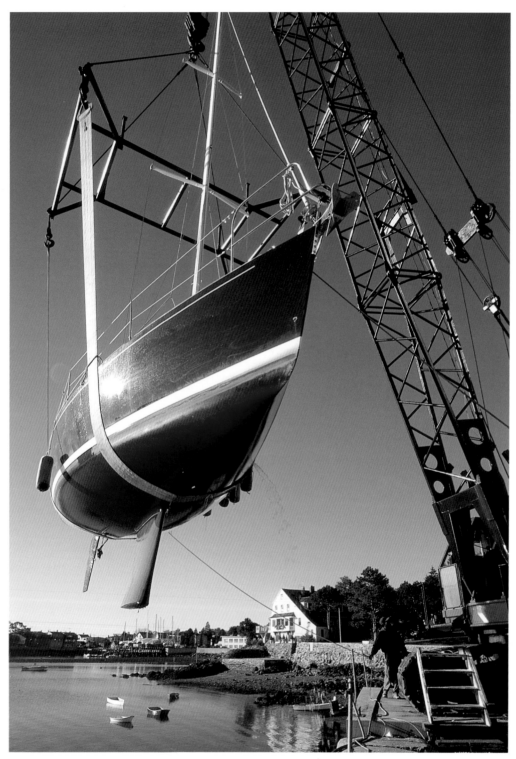

A sloop heads for winter storage at Little Harbor.
This is where Marblehead's first fishermen built their
homes and set up fish flakes to salt and dry their catch.

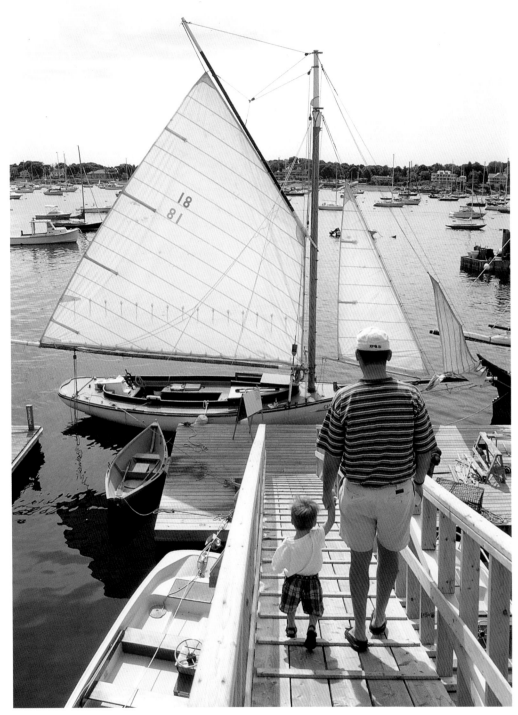

Father and son check out a display of vintage ships
at the Town Landing, Marblehead's main wharf for
over three hundred years.

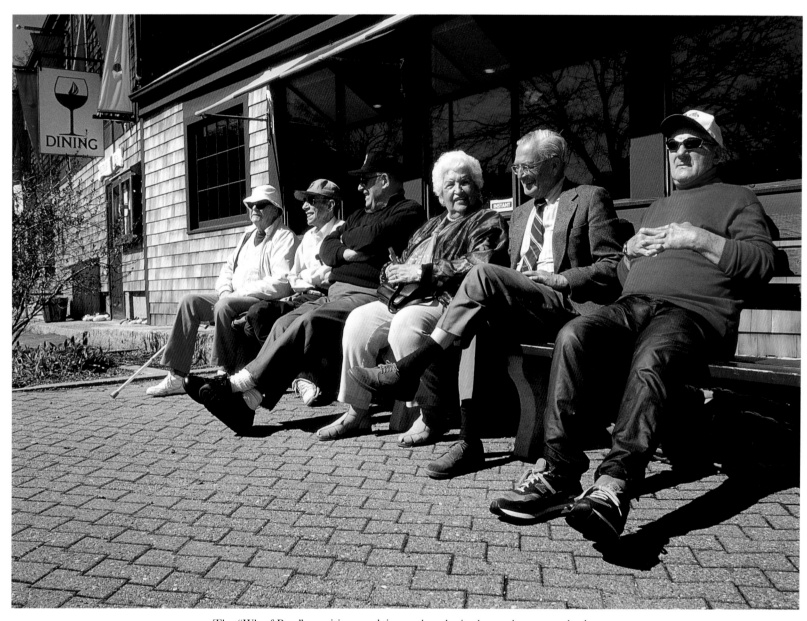

The "Wharf Rats" are citizens at leisure who take in the sea breezes and solve
many of the world's problems. They are named for the four-legged varmints who
used to swim at the Town Landing and sometimes scavenged far up State Street.

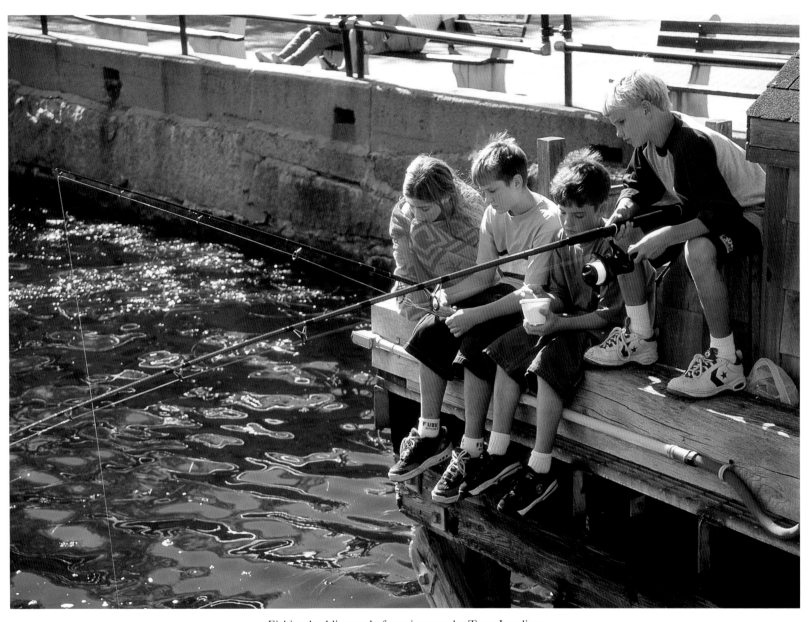

Fishing buddies angle for stripers at the Town Landing.

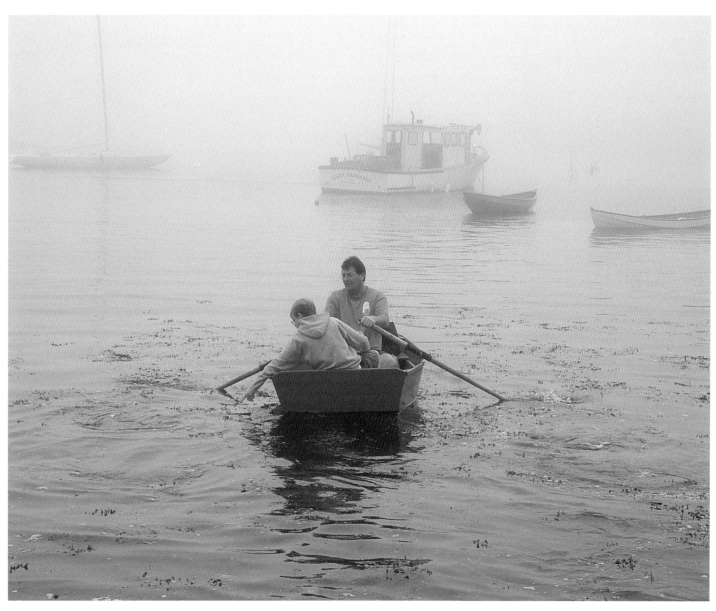

Fog engulfs Little Harbor.

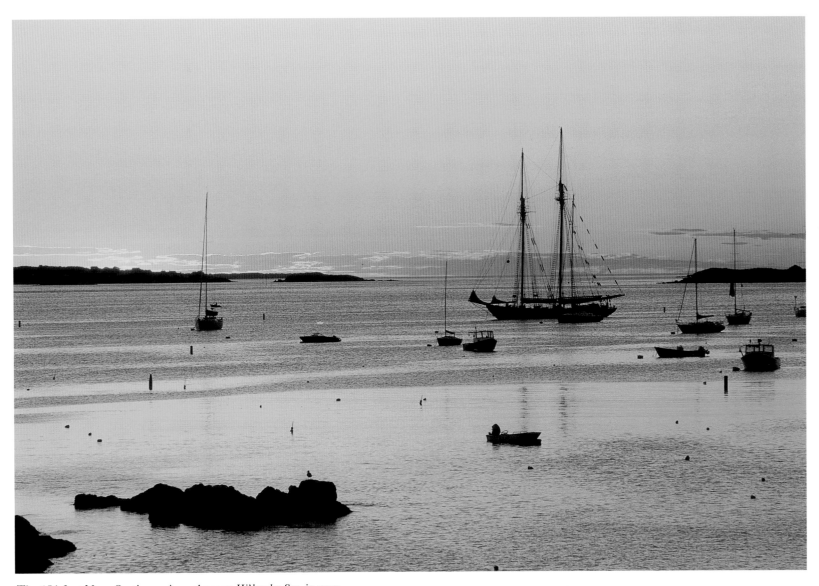

The 154-foot Nova Scotian racing schooner *Hi'lander Sea*, in port.

Round the rocks of Marblehead,

Outward bound, a schooner sped.

Silent, lonesome,

Hannah's at the window binding shoes.

— Lucy Larcom,
"Hannah Binding Shoes"

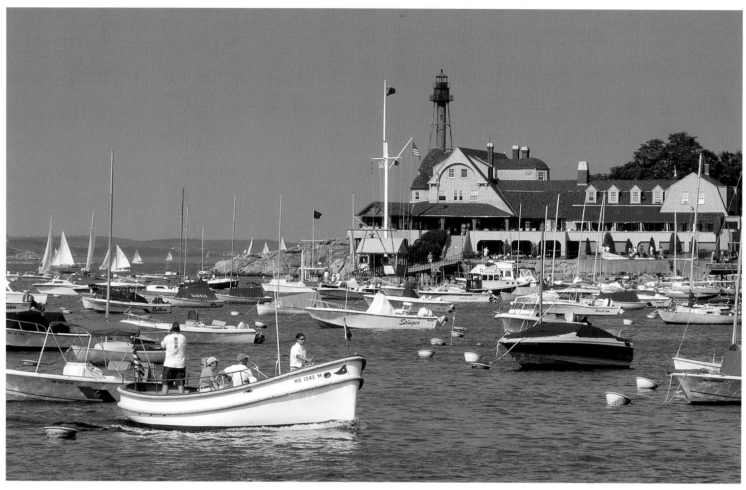

The Corinthian Yacht Club, founded in 1885,
with Marblehead Light beyond.

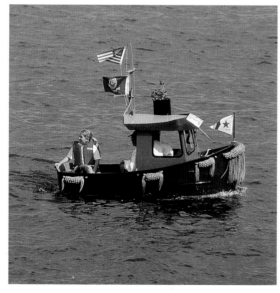

Dick Fowler's *Bump*,
Marblehead's smallest tugboat,
sporting a geranium pot on top,
was declared "Best Water
Garden" during the town's
350th anniversary observance.

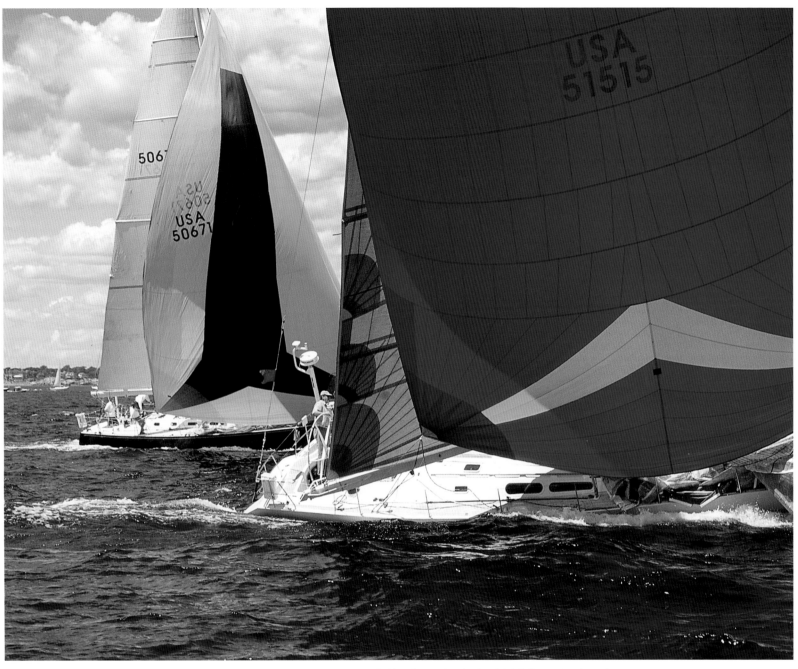

The Halifax Race, from Marblehead to Halifax, Nova Scotia, is a highlight on the American
sailing calendar that takes place in odd-numbered years. The start, off Marblehead, is an
occasion of great color and excitement.

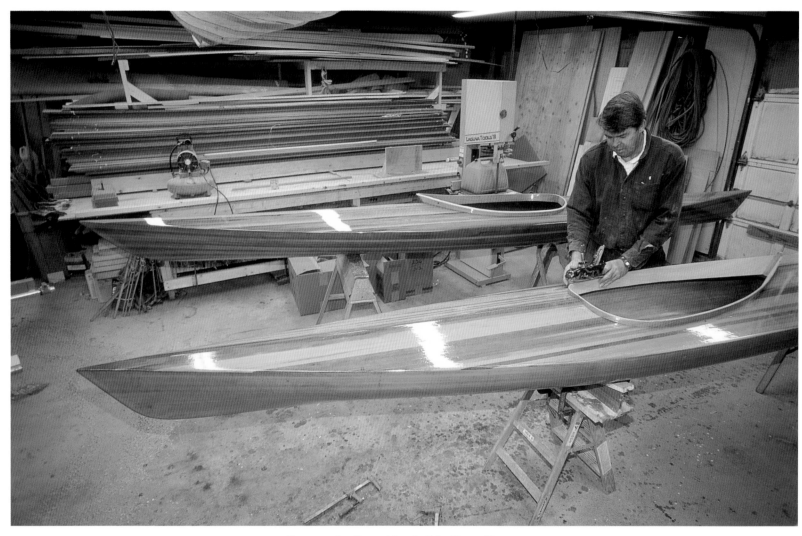

Renowned sailor and boatbuilder Bruce Dyson
finishes a wooden kayak.

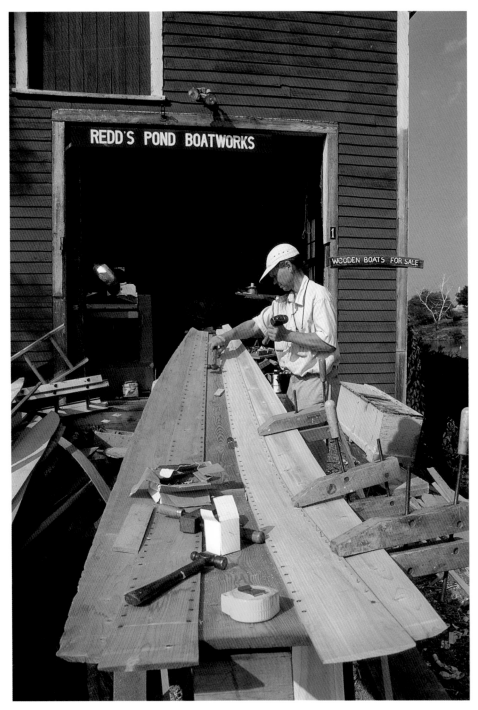

Thad Danielson rivets a Norwegian pram
at the barn on Redd's Pond.

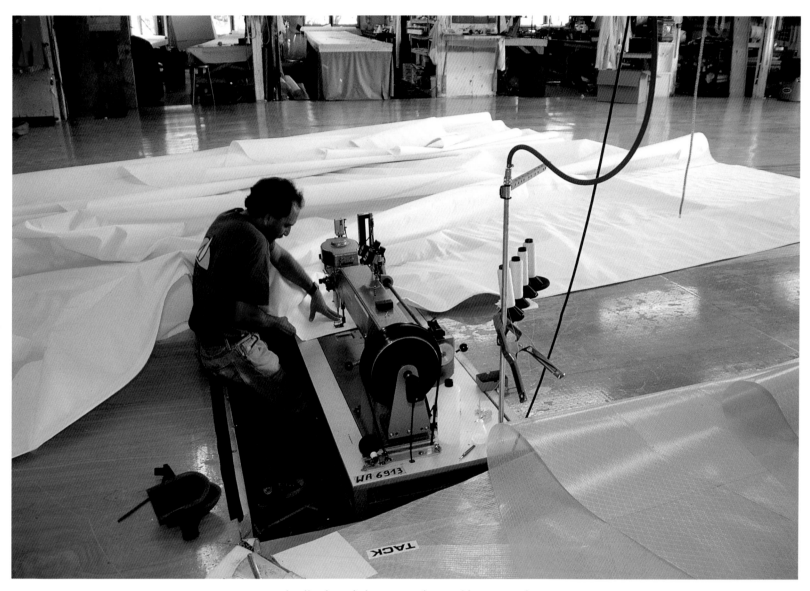

A sailmaker stitches at a sewing machine recessed
in a floor well at Doyle Sailmakers on Front Street.

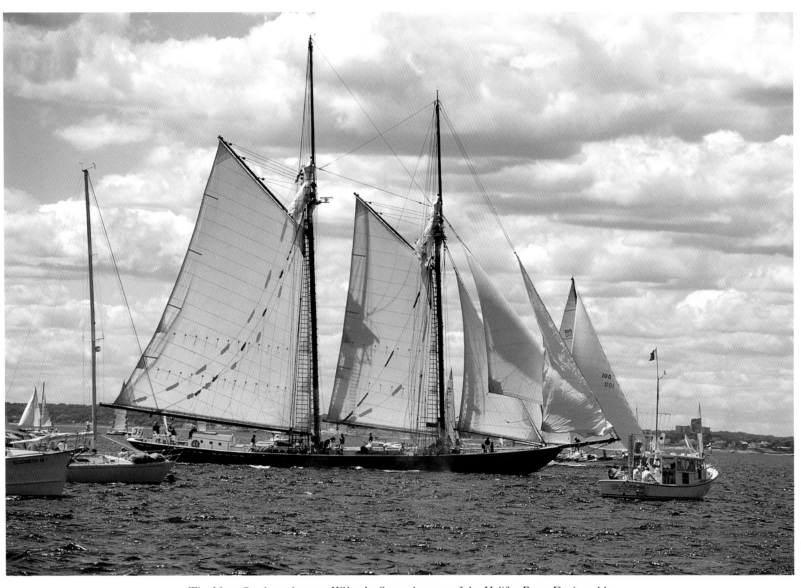

The Nova Scotian schooner *Hi'lander Sea* at the start of the Halifax Race. Designed by
W. Starling Burgess and built in Essex in 1924, she was a pilot vessel in Boston Harbor for forty-
seven years before being acquired by a member of the Royal Nova Scotia Yacht Squadron.

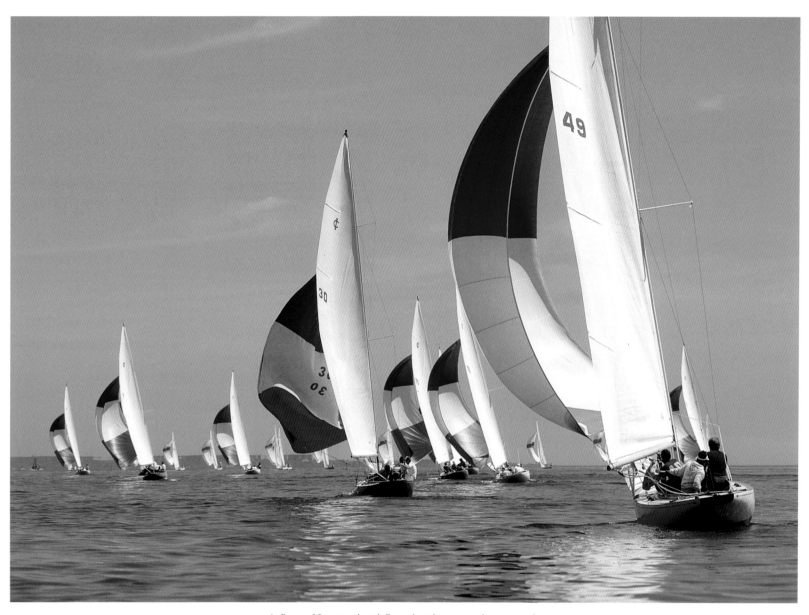

A fleet of International Ones head out on a beam reach
during Marblehead's annual Race Week, held in July.

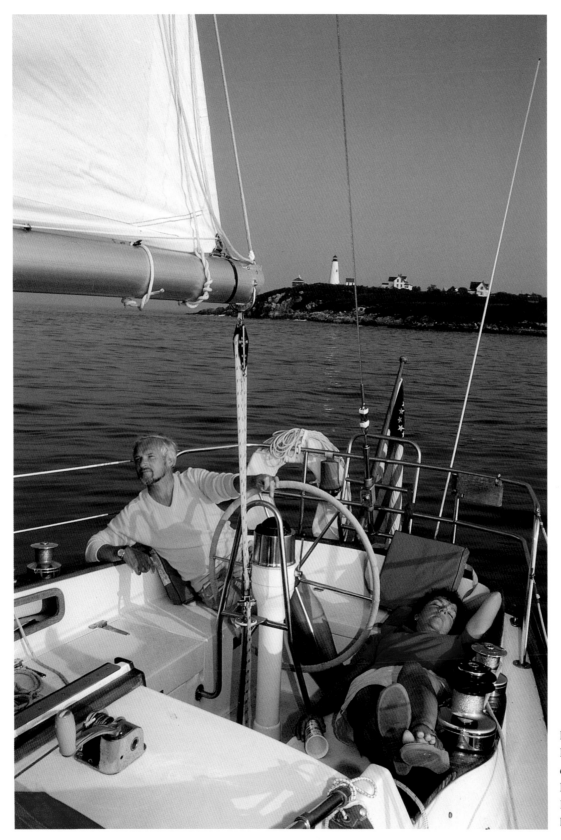

Dieter and Margie Empacher enjoy a day's sail off Marblehead with Baker's Island Light looming astern.

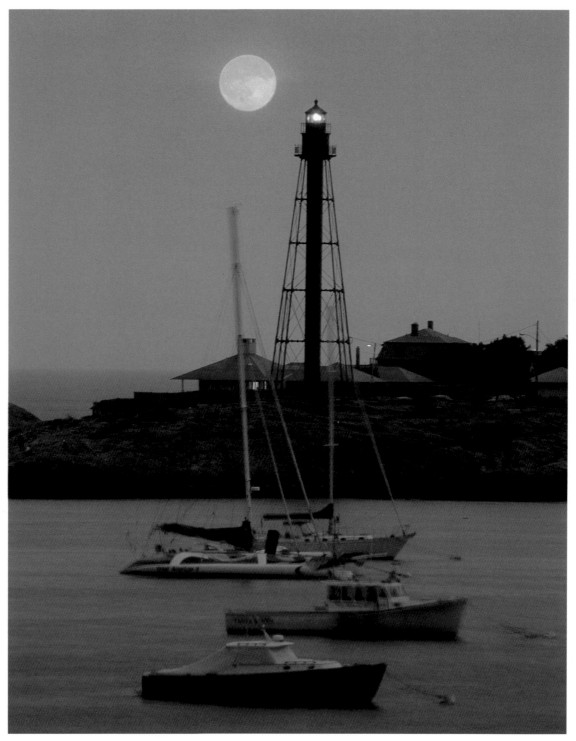

Full moon over Marblehead Light, built in 1896.
The previous lighthouse at this location was made of stone.

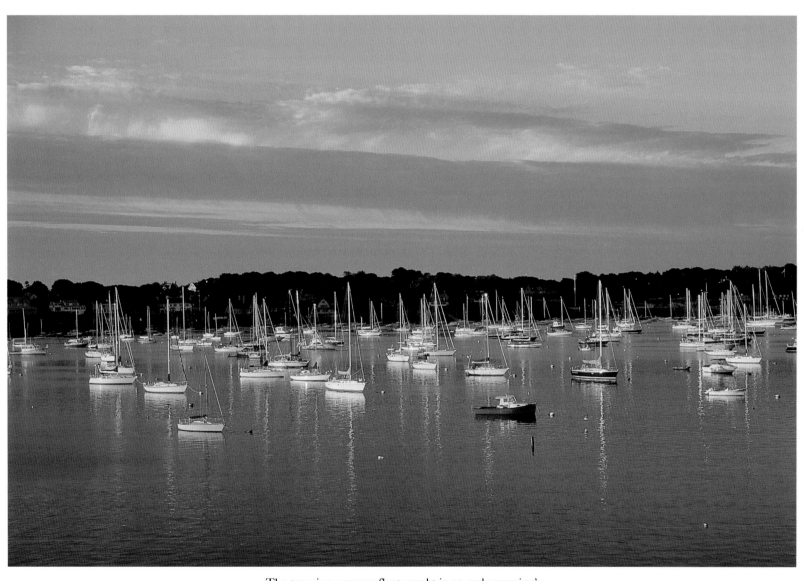

The teeming summer fleet caught in an early morning's
glow, with Marblehead Neck beyond.

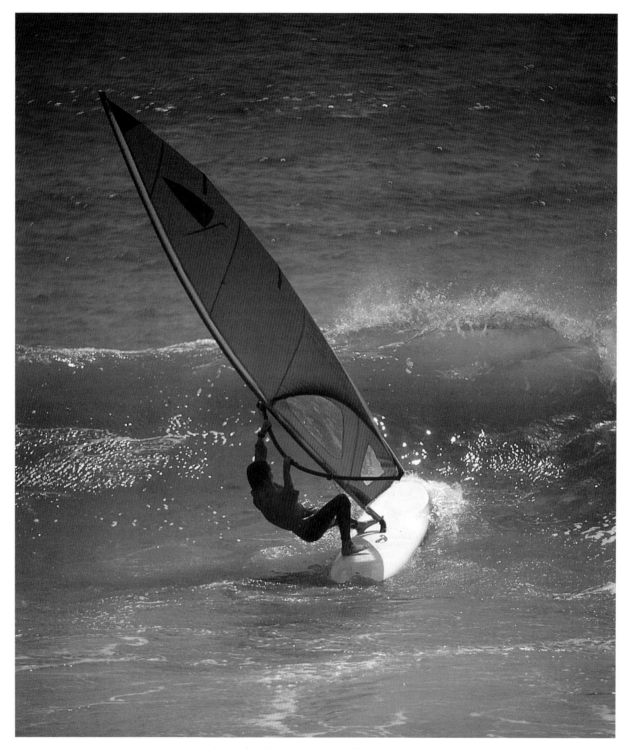

A windsurfer rides the waves at Devereux Beach.

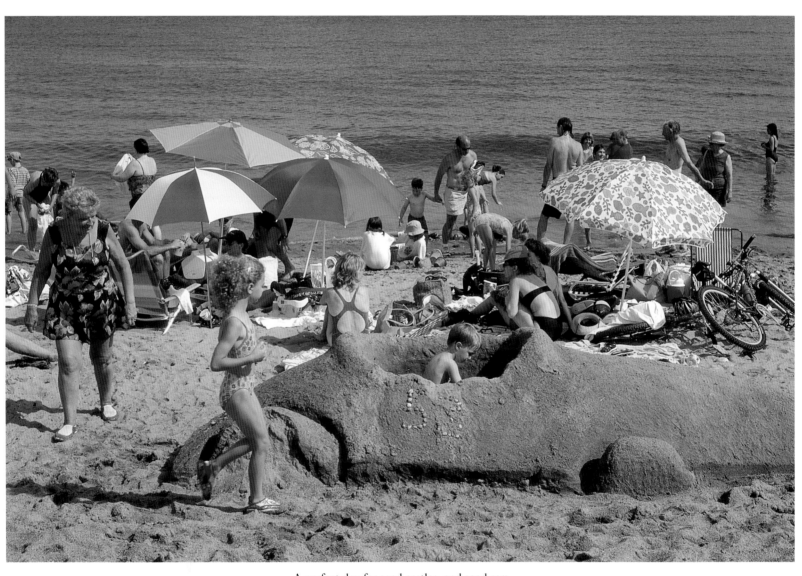

A perfect day for sand castles, and sand cars,
on Devereux Beach.

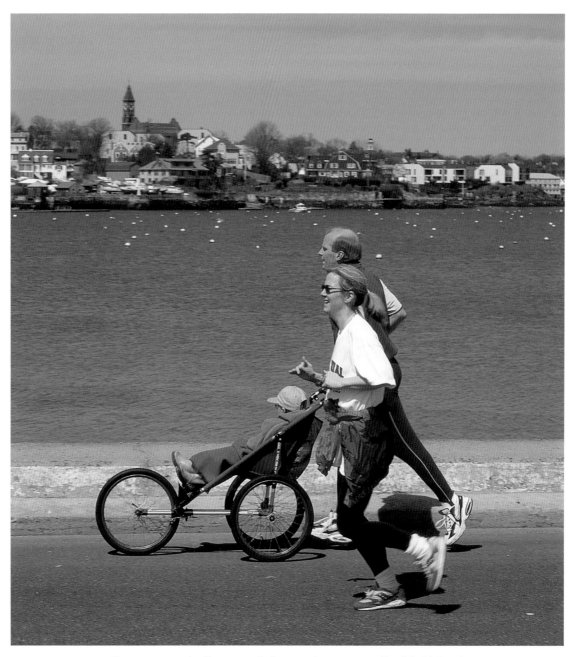

Runners cross the Causeway during a spring race rounding Marblehead
Neck. In the days of the Naumkeags, when Marblehead was called
Massabequash, the Causeway was nothing but a sand bank.

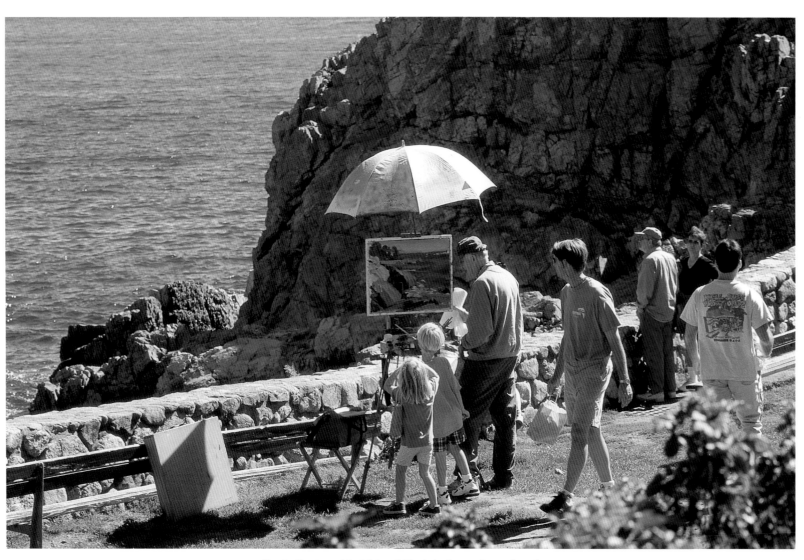

Castle Rock on Marblehead Neck is the perfect painter's
vantage point. Scenes for Mary Pickford's silent movie
The Pride of the Clam were filmed here.

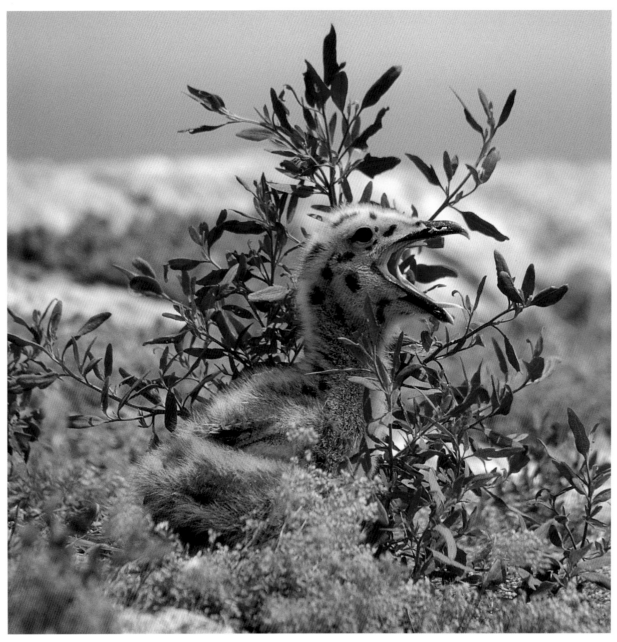

A baby seagull cries for its supper on Children's Island,
owned by the Marblehead-Swampscott YMCA.

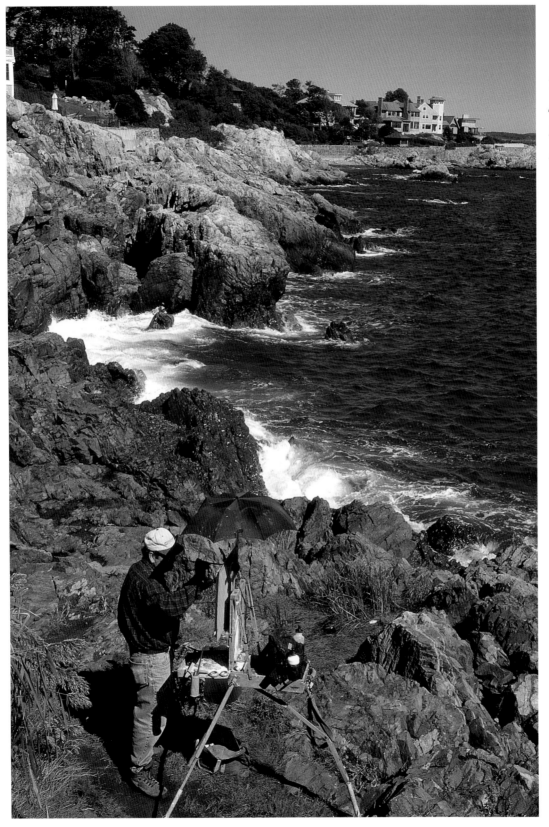

They have covered a bare
and uncouth cluster of gray
ledges with houses and
called it Marblehead.

— *New England
Legends and Folklore*

At Castle Rock, a painter
captures the collision of water
and ledge that has always
defined Marblehead.

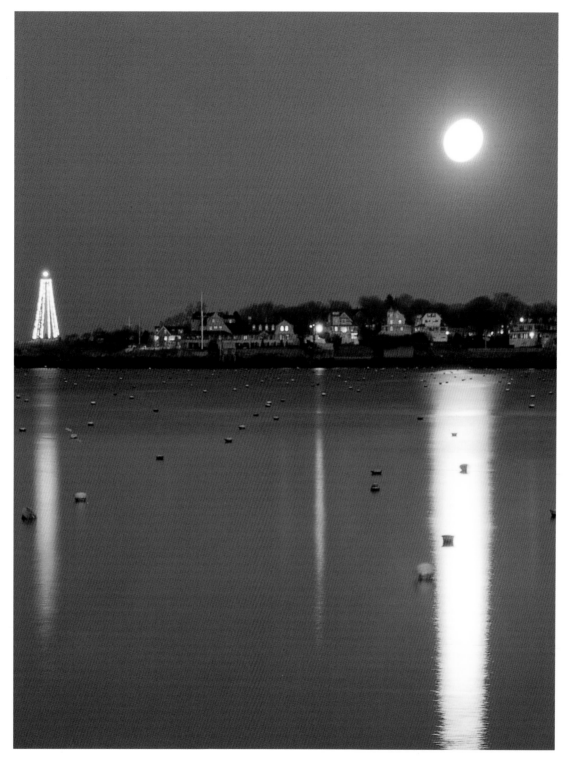

A winter moon competes in brilliance with Marblehead Light,
strung with extra lights for the holiday season.

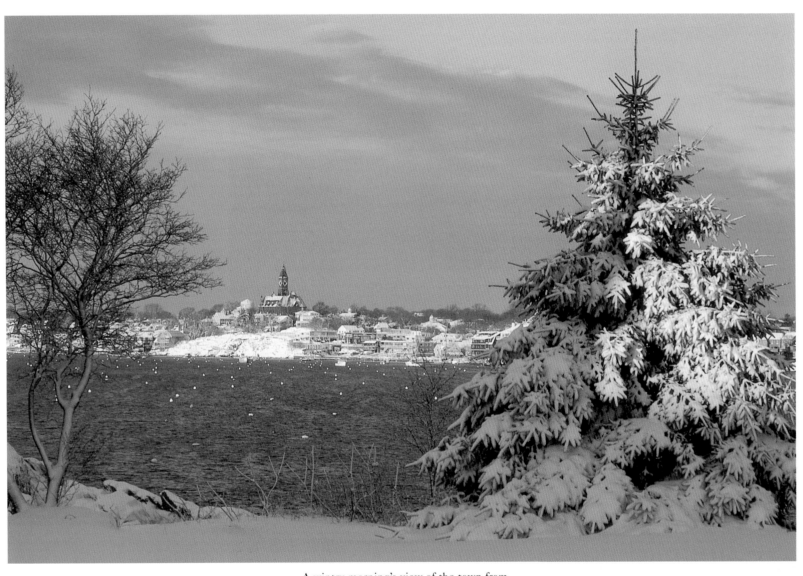

A wintry morning's view of the town from
Chandler Hovey Park on the Neck.

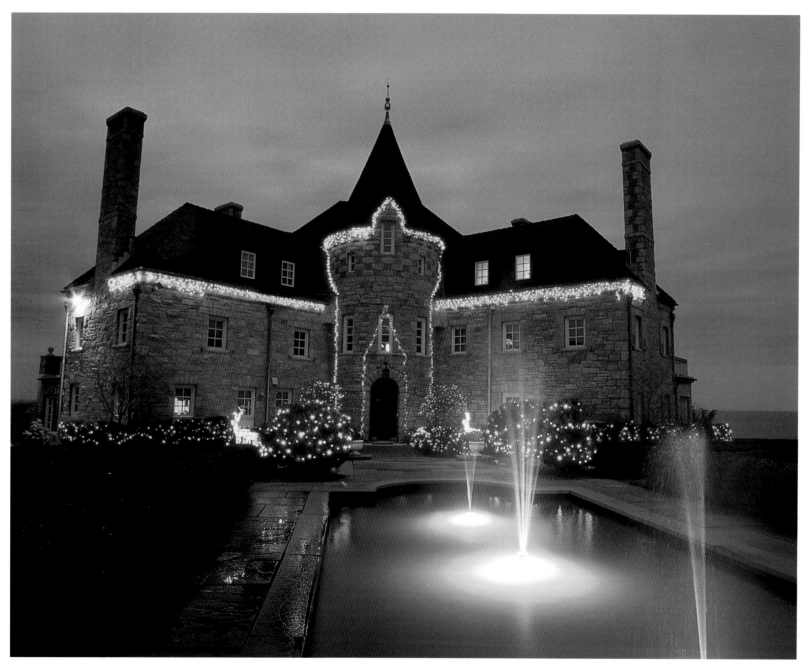

"Carcassonne," also known as "The Castle,"
was built in 1934 for $500,000.

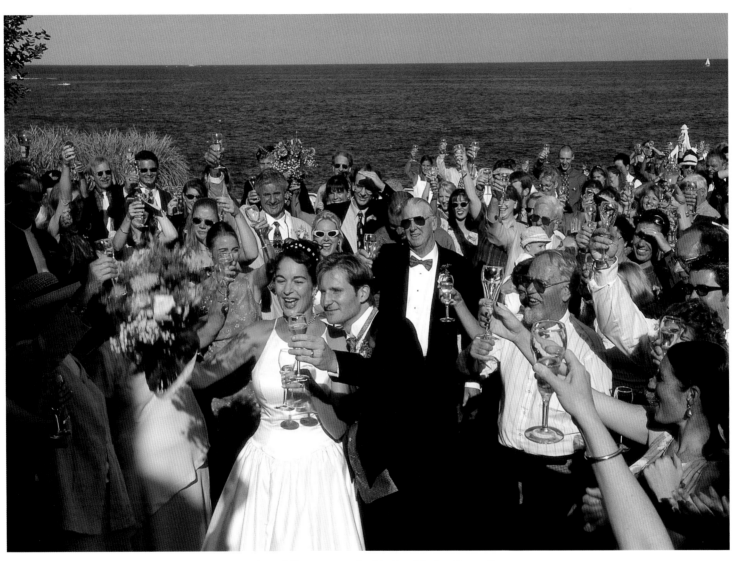

A wedding toast on the Neck, with the glitter of
the North Atlantic beyond.

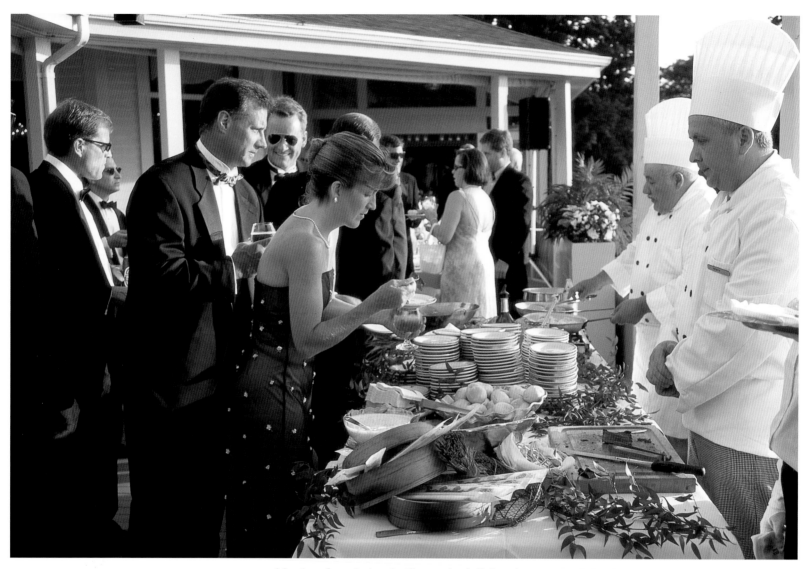

Members feast during the Commodore's Ball at the
Eastern Yacht Club, founded in 1870.

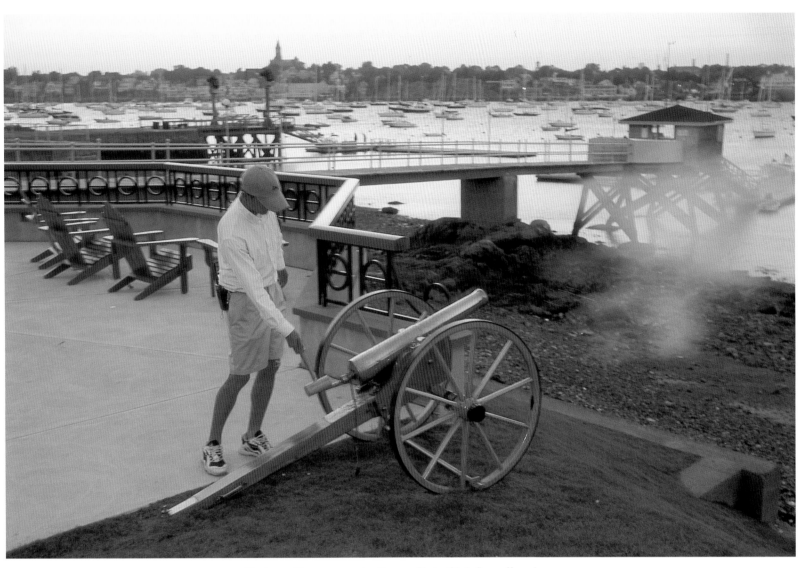

During sailing season, the Eastern Yacht Club fires off a salute
at eight o'clock in the morning and at sundown—though never on Sunday.

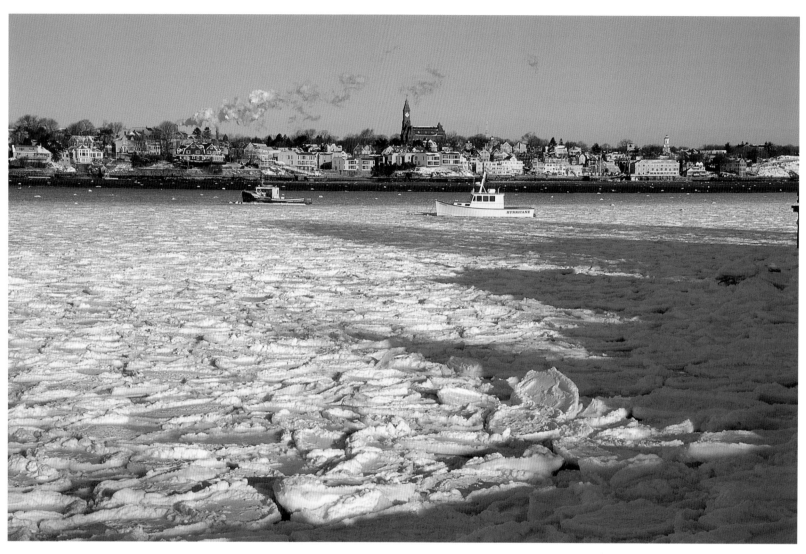

In the coldest of winters, Marblehead Harbor will freeze over.

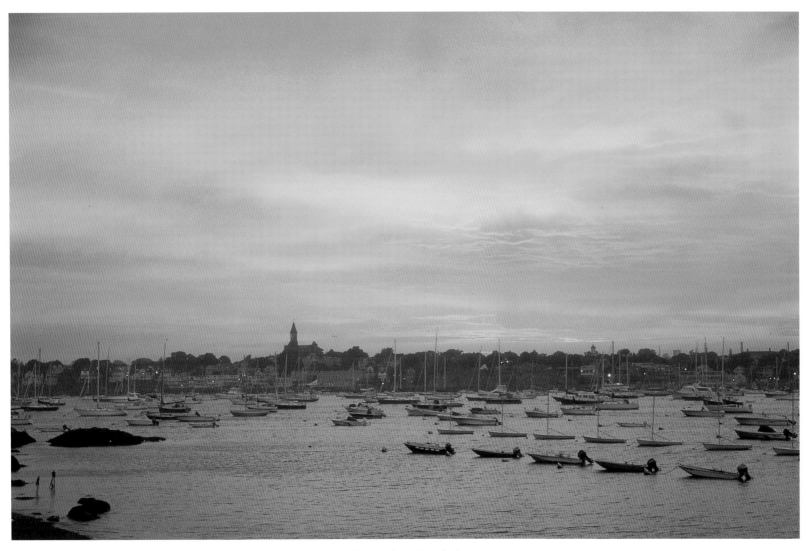

Sunset, from the Neck.

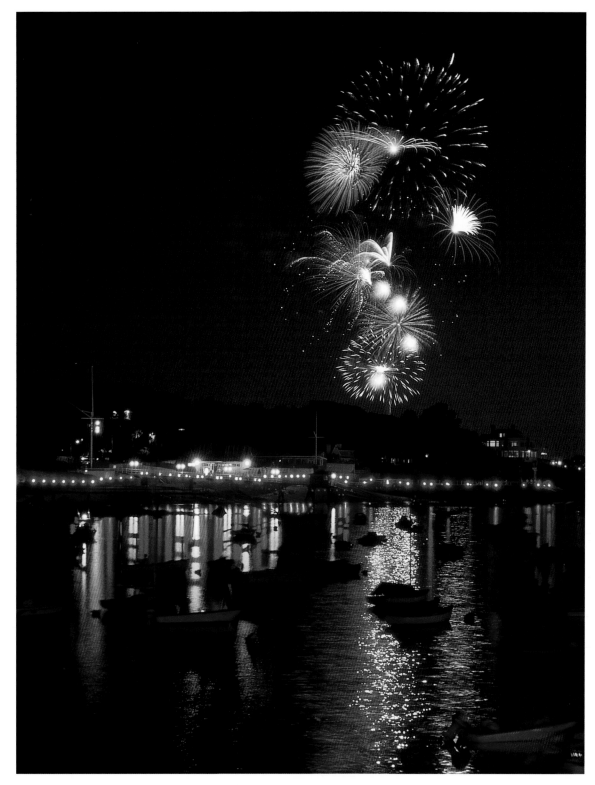

Fourth of July fireworks, looking from the
Corinthian Yacht Club toward the Eastern Yacht Club.

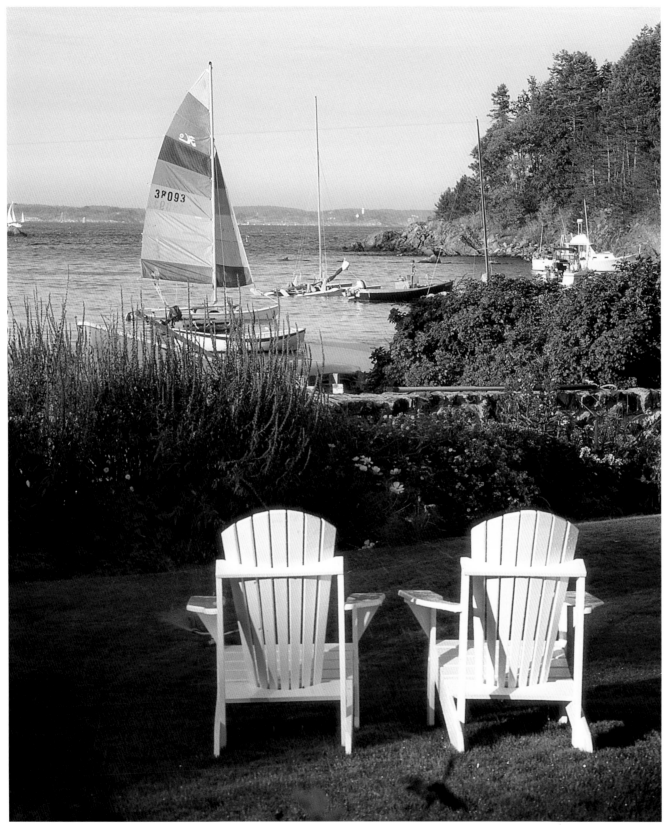

The inhabitants built their houses anywhere, provided only that they owned the land, and there was no arbitrary custom to dictate which end should be the front, or which the back.

—Samuel Roads, Jr.,
*History and Traditions
of Marblehead*

A view of
Doliber's Cove.

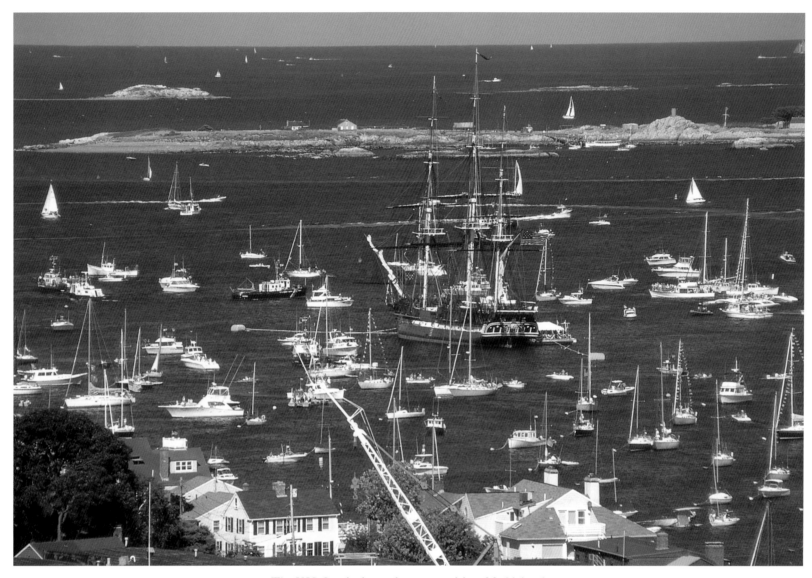

The USS *Constitution* made a return visit to Marblehead
Harbor in 1997, on her two-hundredth anniversary.

Here be a good harbour for boates,

and safe riding for shippes.

—William Wood,
New England Prospects,
seventeenth century

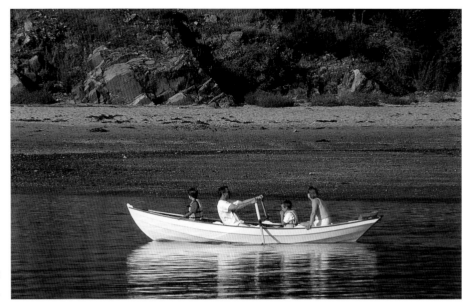

A dory rows past
Crowninshield Island.

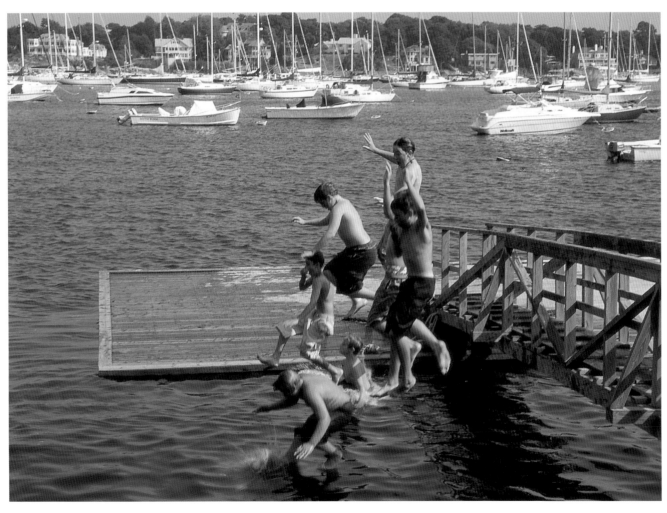

Kids dip into the
harbor from the
Crocker Park pier.

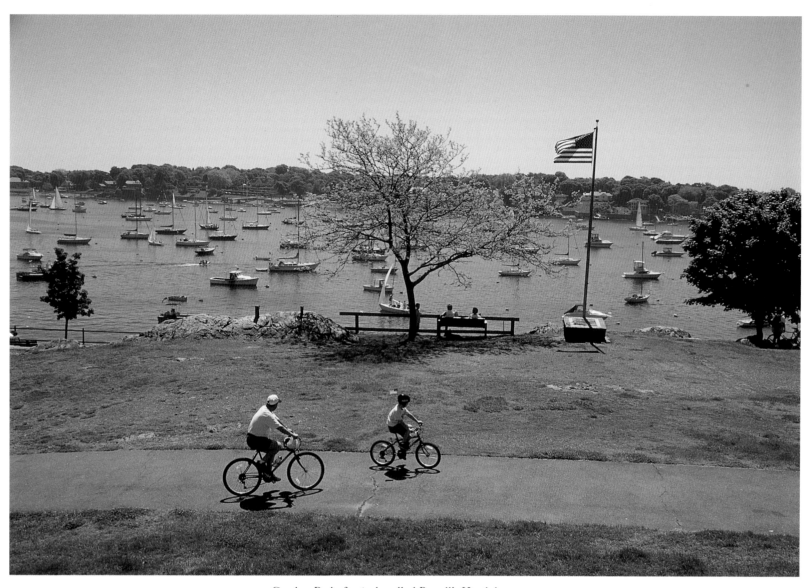

Crocker Park, formerly called Bartoll's Head, became
Marblehead's first public recreation area in 1886.

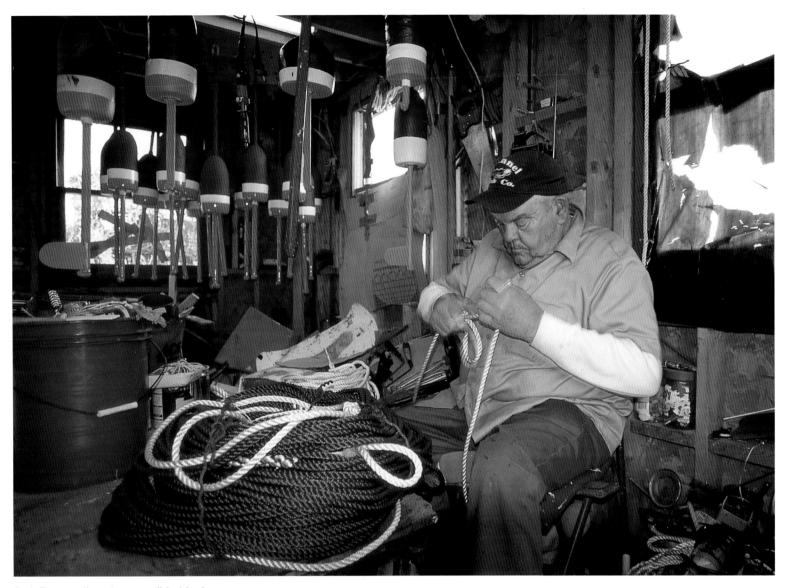

Jack Burns splices "pot warp" in his shanty.

The whole township is not much bigger than a small farm, and very rocky, and so they are forc't to get their living out of the sea.

—Josiah Cotton, schoolmaster in Marblehead, 1698–1704

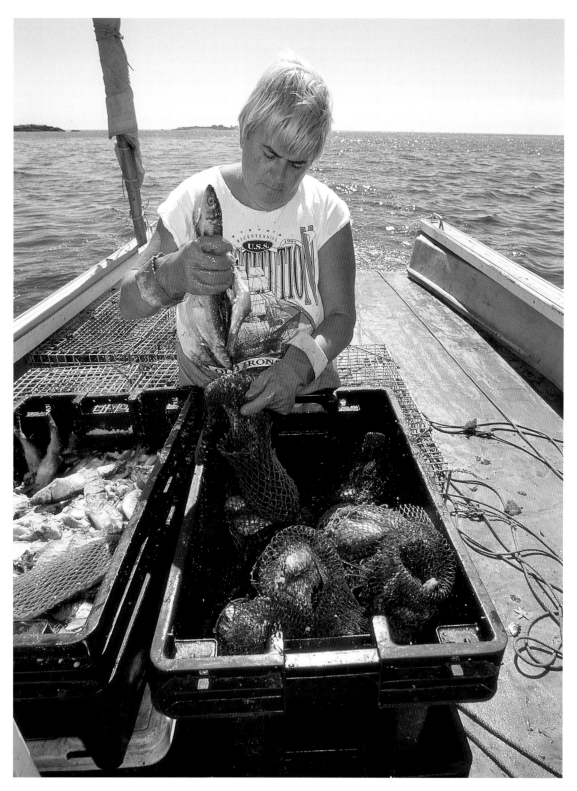

Susan Michaud fills bait sacks with herring on the
lobster boat she works with her husband, Jay.

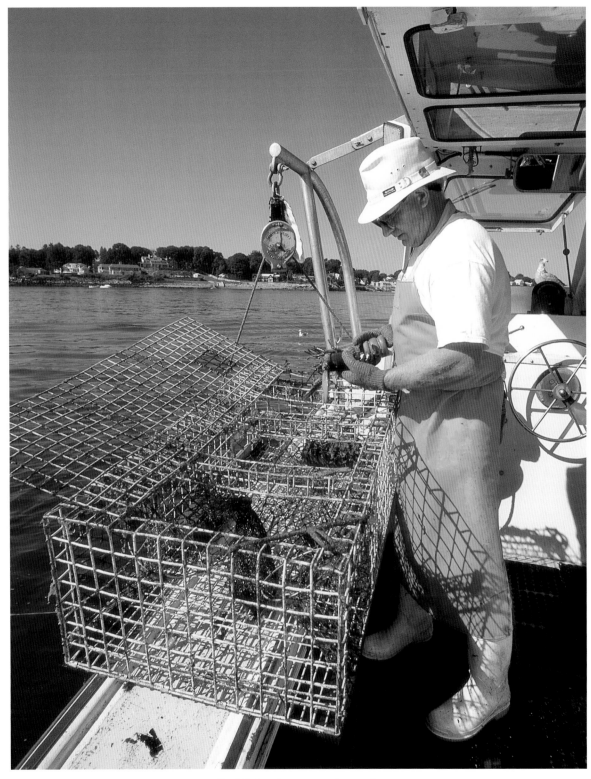

Jay Michaud measures the catch.

A dory returns to harbor.

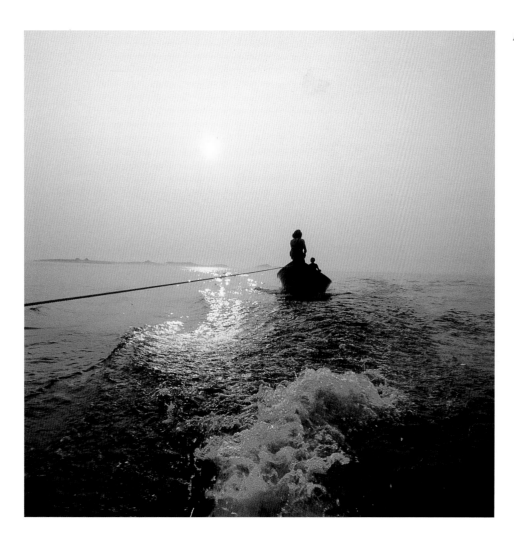

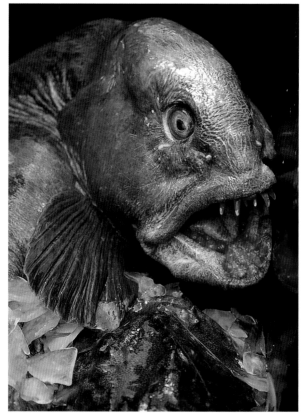

The wolf fish is ferocious to look at,
but delicious to taste.

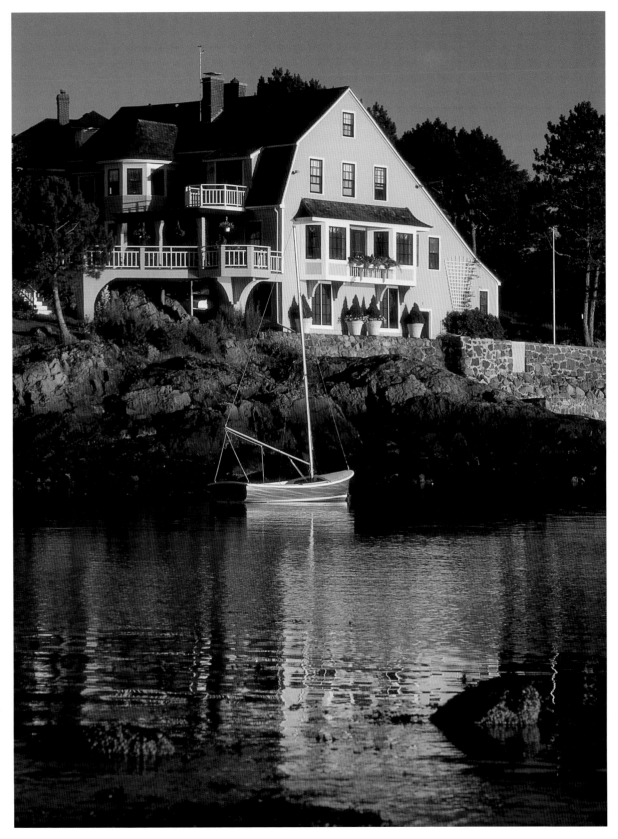

Morning's light at Little Harbor.

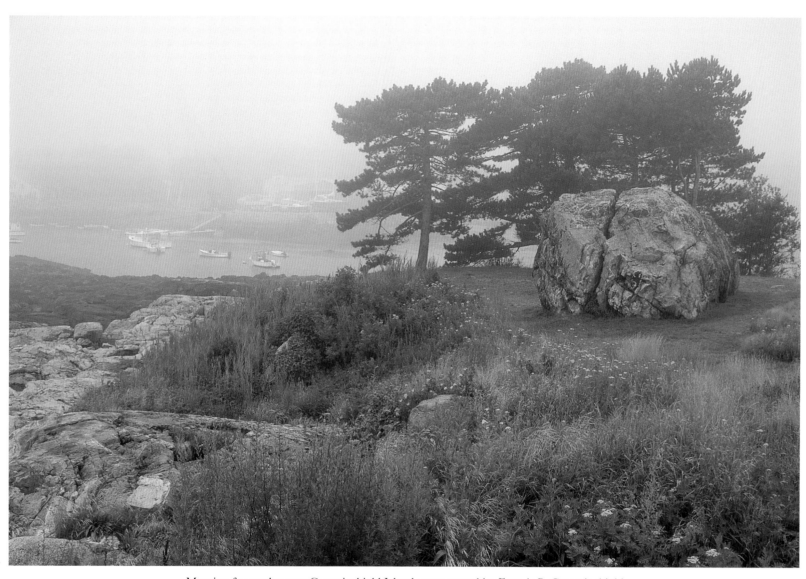

Morning fog settles over Crowninshield Island, once owned by Francis B. Crowninshield
and his wife, the former Louise DuPont. Mrs. Crowninshield, who had many trees
planted here, later donated the island to the Trustees of Reservations.

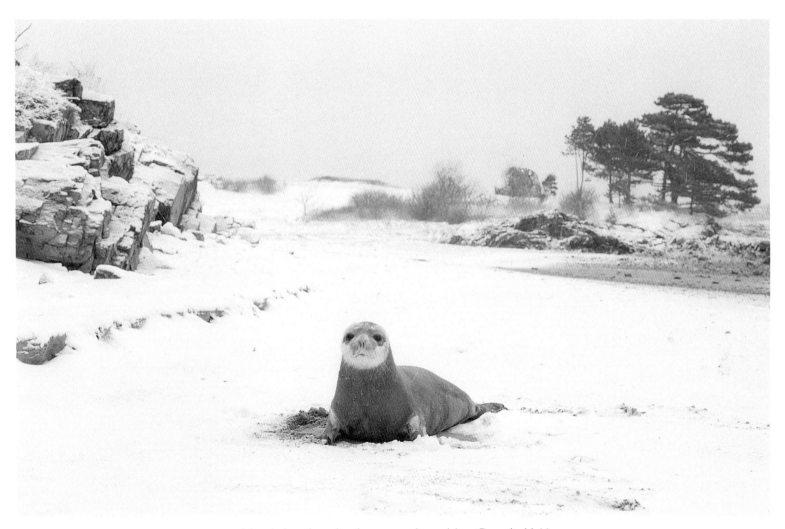

A hooded arctic seal makes a rare winter visit to Crowninshield
Island. He beached himself on the shallow landward side, but was
eventually transported to the deep ocean side, where he swam free.

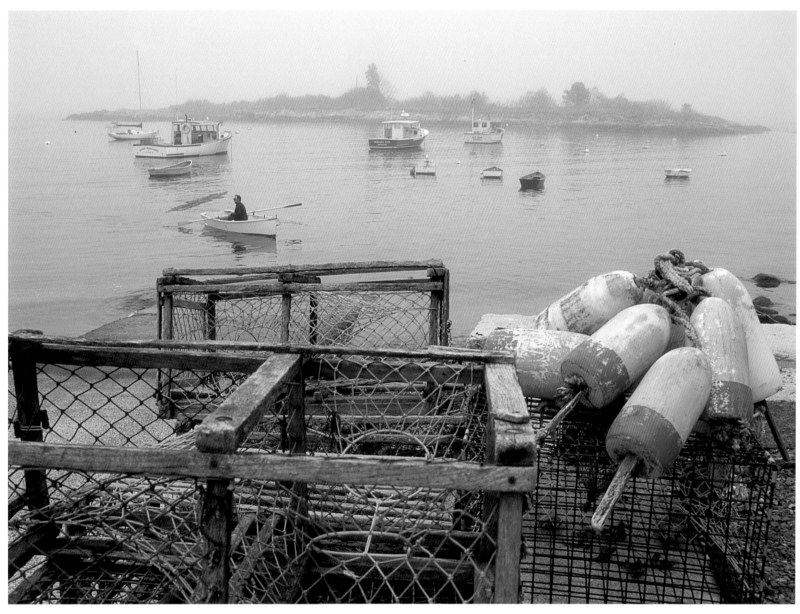

Lobster traps at Little Harbor, with Gerry Island in the distance.

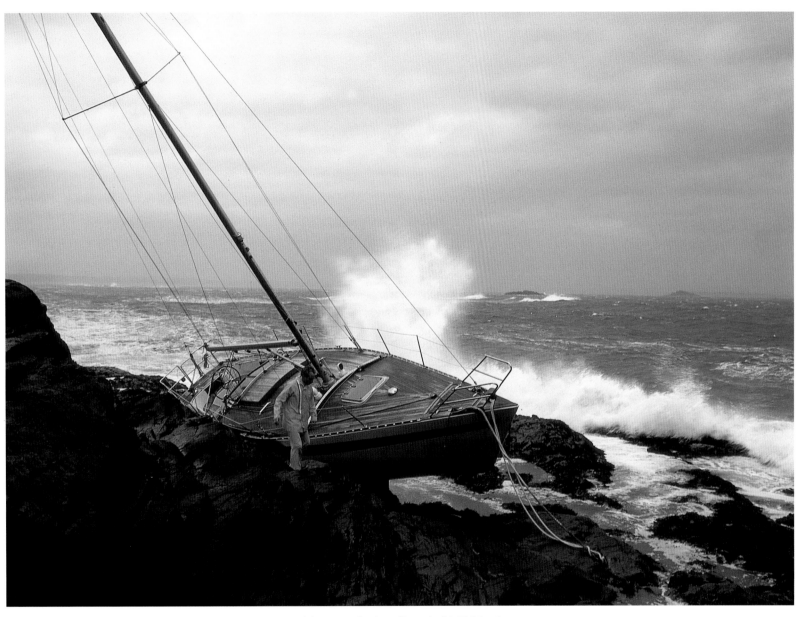

A boat wrecked on Crowninshield Island
during 1985's Hurricane Gloria.

THE TOWN

Beauty, charm, and eccentricity lie around
each oddly angled corner of downtown
Marblehead, where colorful homes from every
period jostle for space. No wonder artists gawk,
while residents and visitors love to walk.

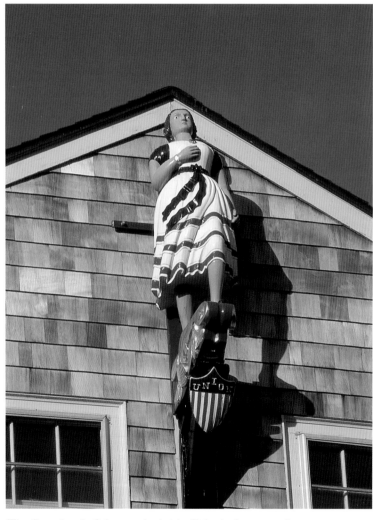

The figurehead of the wrecked ship *Union* looks seaward
from atop a home on Beacon Street, while the steeple of
Old North Church looms from Gerry Island in the light
of an early morning.

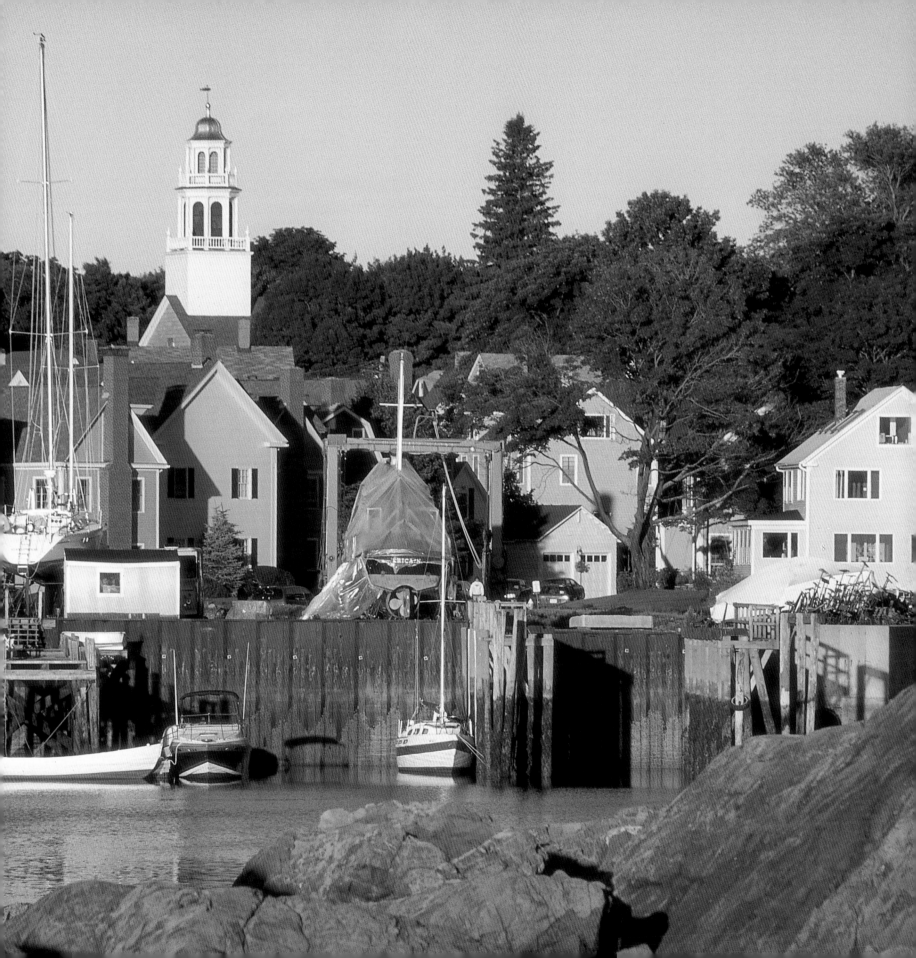

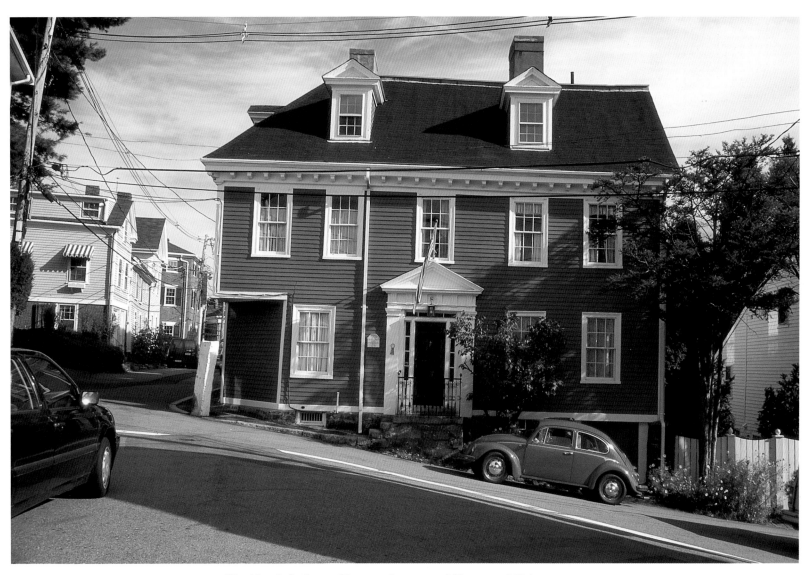

The historic Lafayette House at the corner of Hooper and Union streets,
so named because legend says a corner of the house had to be removed to
make way for the Marquis de Lafayette's triumphal visit in 1824.

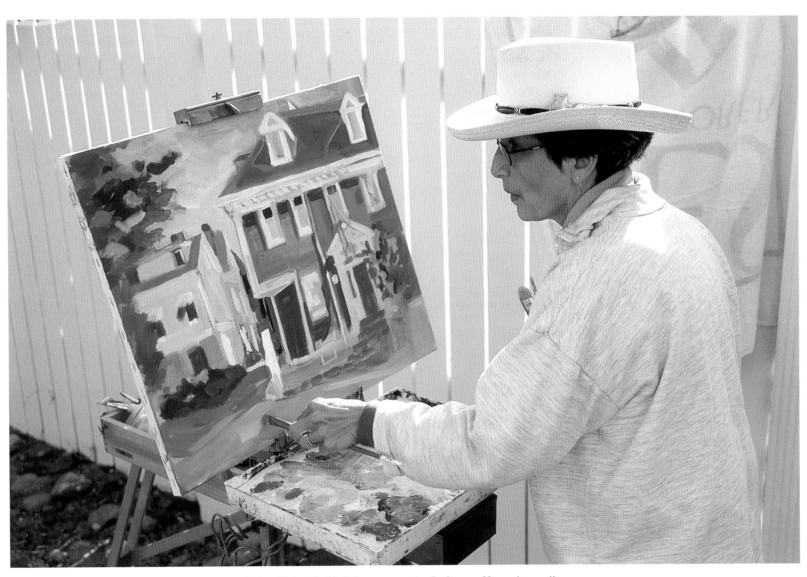

Artist Elaine Caliri Daly captures the Lafayette House in acrylics.

As nature abhors a straight line,
so too does the Marbleheader.

— An Outline of
Marblehead History

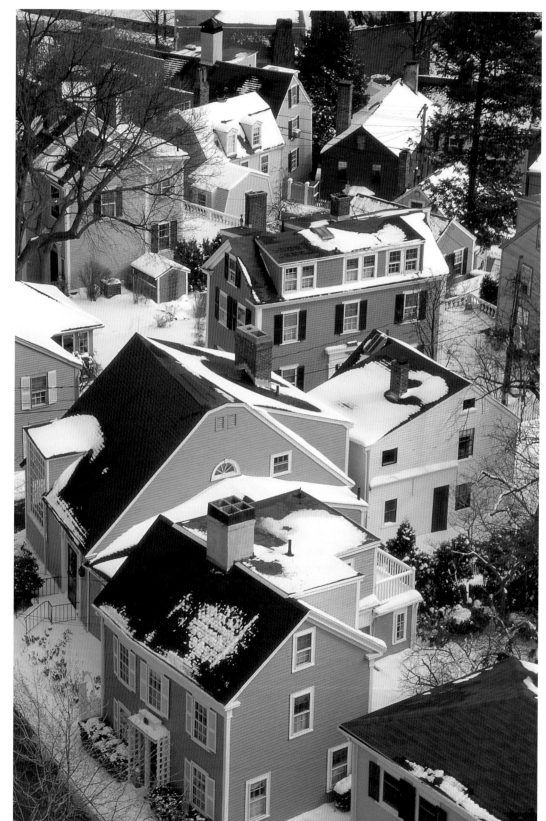

The heart of the old town viewed
from the tower of Abbot Hall.

80

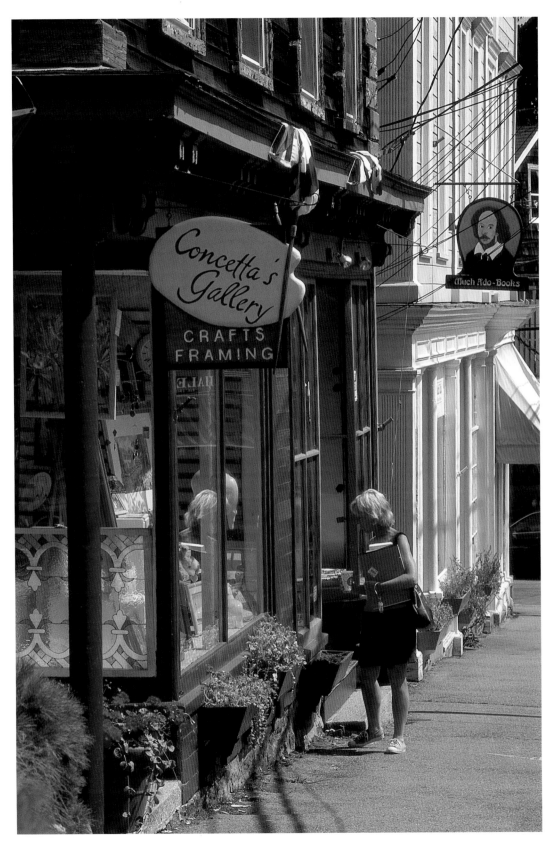

Window-shopping on
Pleasant Street.

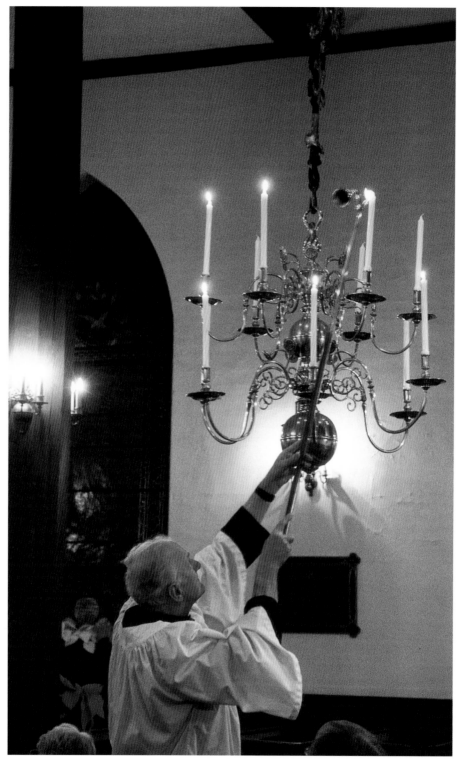

A sexton lights the brass chandelier at St. Michael's Church.
Crafted in Italy, it was a gift of John Elbridge, Esq., of Bristol, England.

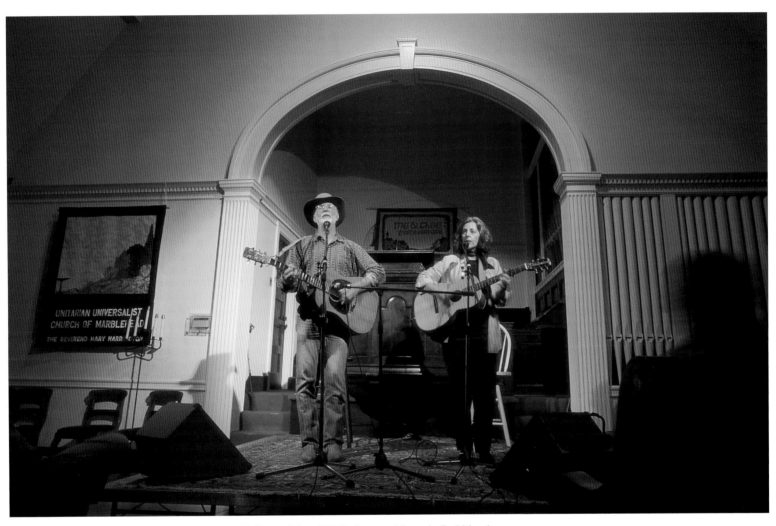

Folk musicians Bill Staines and Jeannie Stahl lend an extra
glow to the "me and thee" coffeehouse, a fixture at the
Unitarian Church on Mugford Street since 1970.

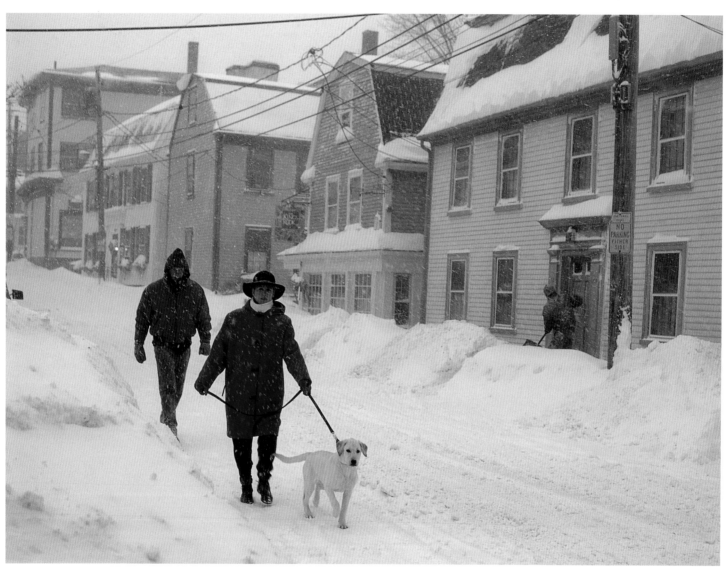

Blizzard on State Street.

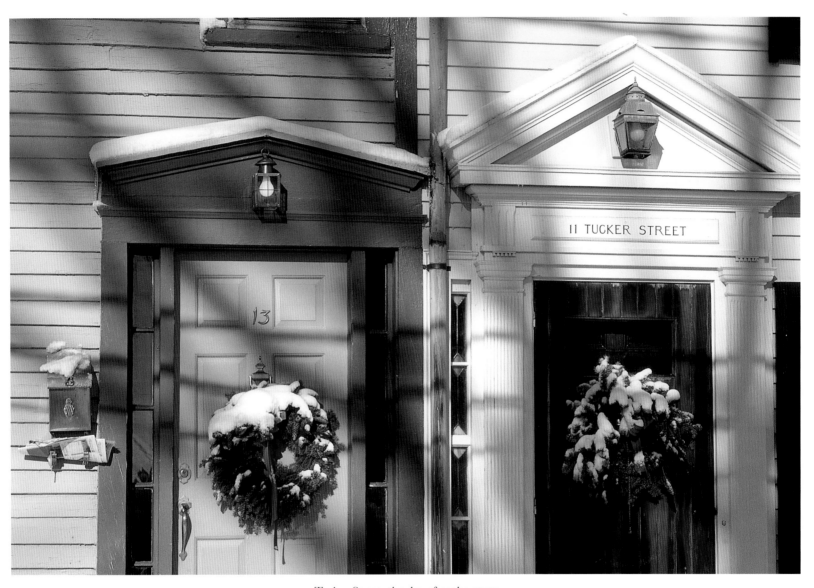

Tucker Street, the day after the storm.

A close-up on Washington Street.

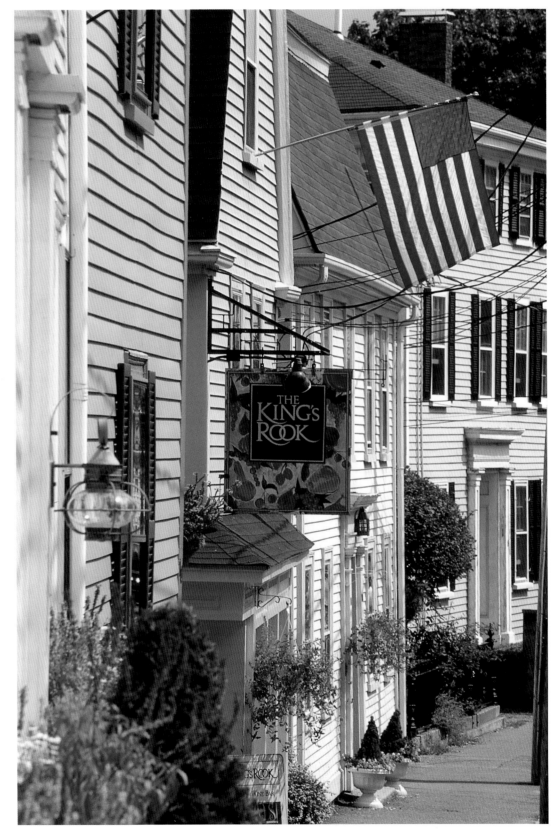

Marblehead is one of the four most attractive towns in America.

— *New York Times*

A view down State Street.

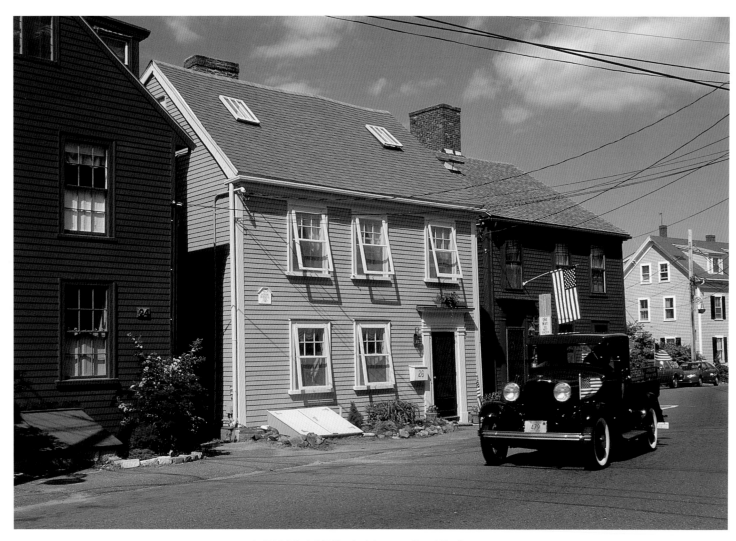

A 1932 Model B Ford pickup on Franklin Street.

Summer on Dunn's Lane.

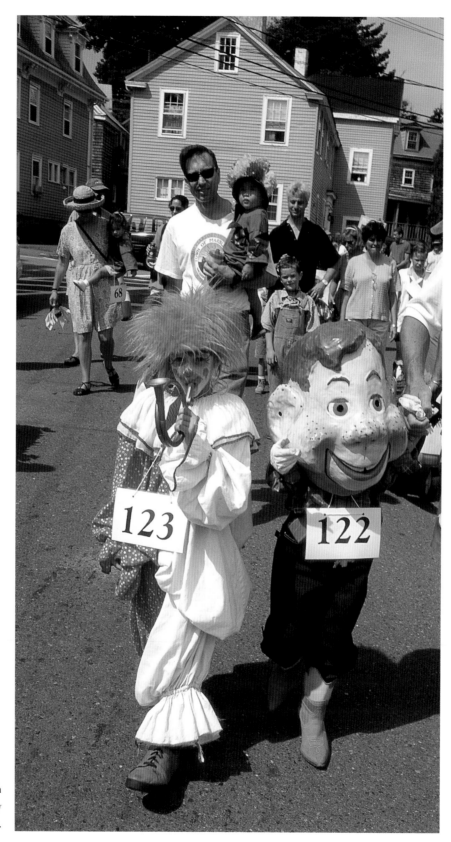

The Horribles Parade, a Fourth
of July favorite, makes its way
up Washington Street.

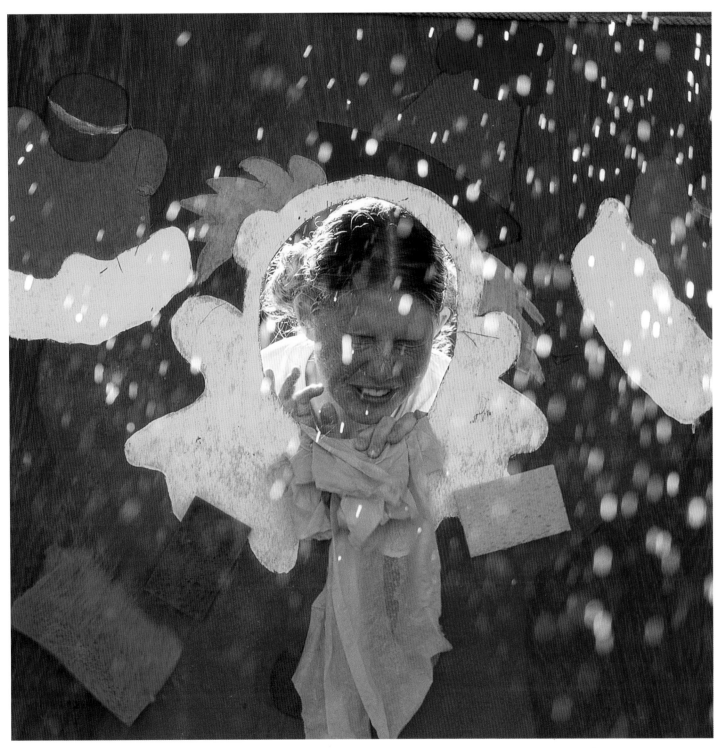

A happy target for sponges at the YMCA's summer day camp.

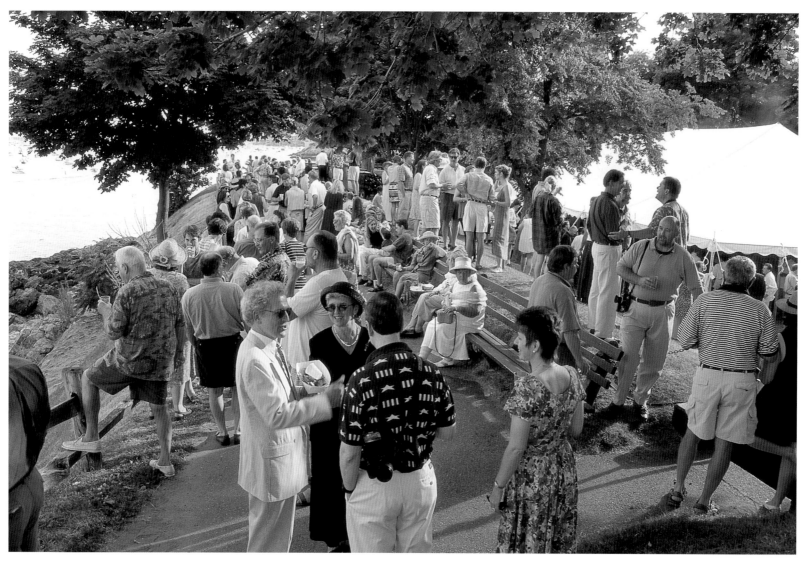

A champagne reception kicks off the Marblehead Festival
of the Arts, begun in 1963.

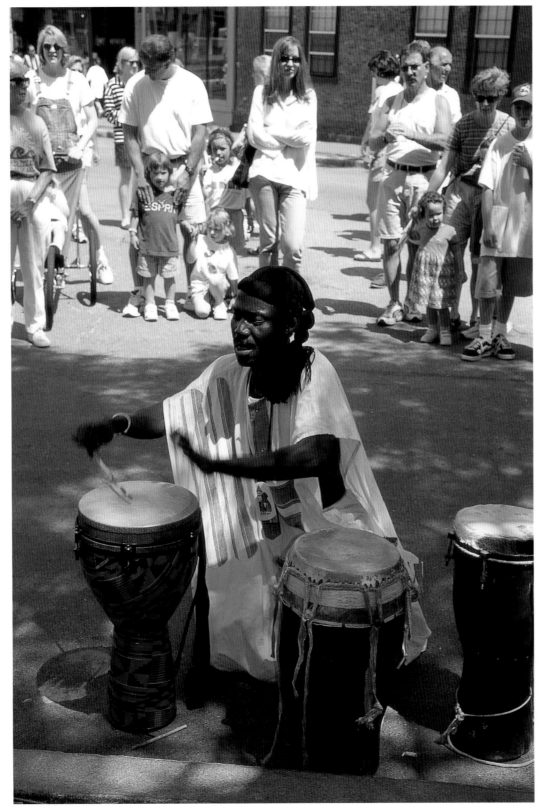

Drummer Mamadou enlivens
Market Square during the Festival
of the Arts.

93

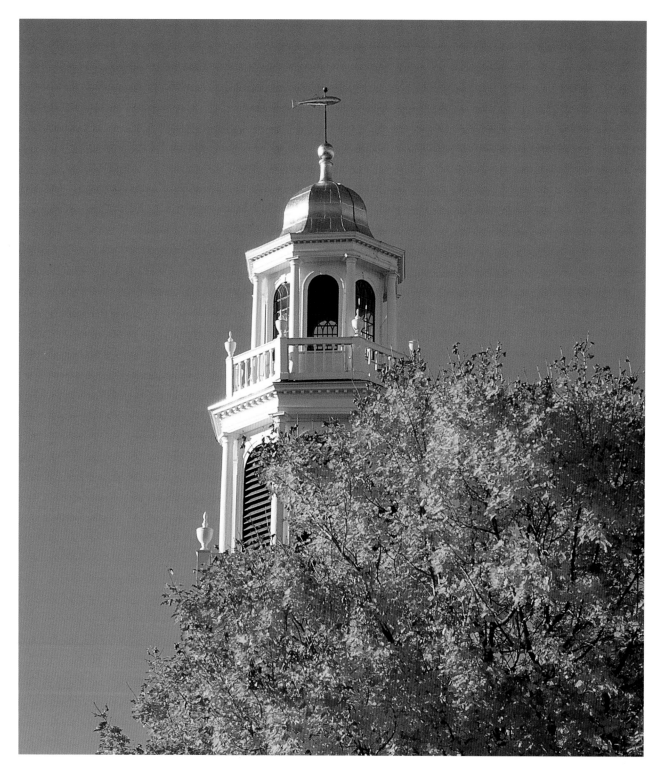

Old North Church in autumn.

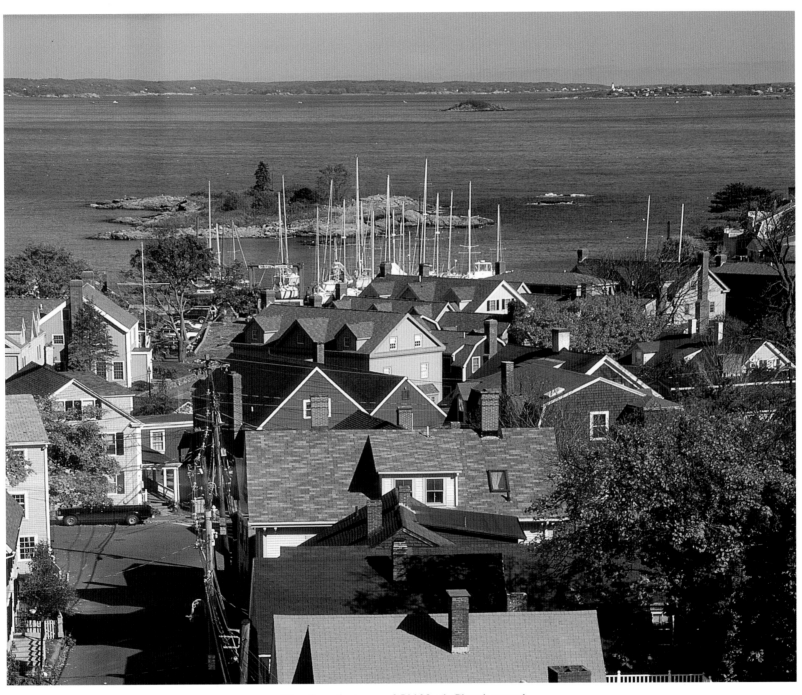

View from the tower of Old North Church toward
Gerry Island and the upper North Shore.

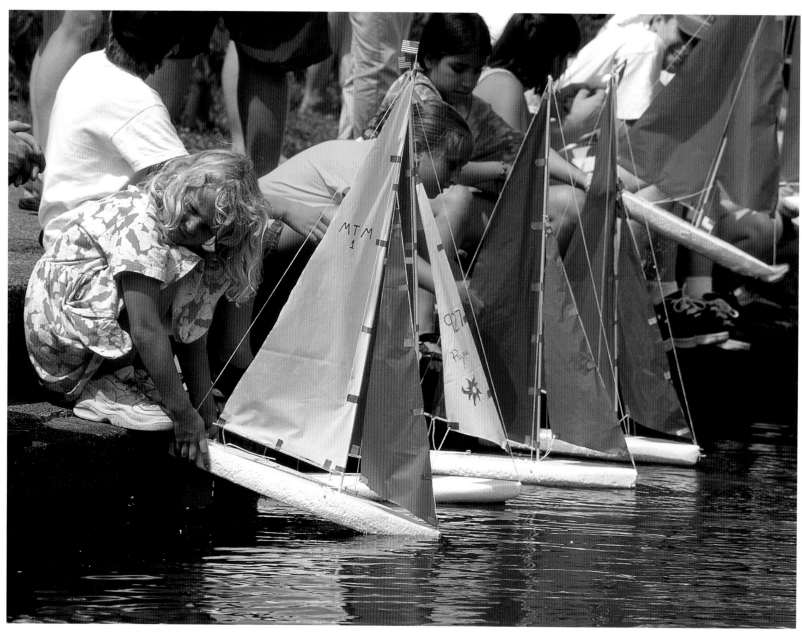

During the Festival of the Arts, children build their own
sailboats and sail them on Redd's Pond.

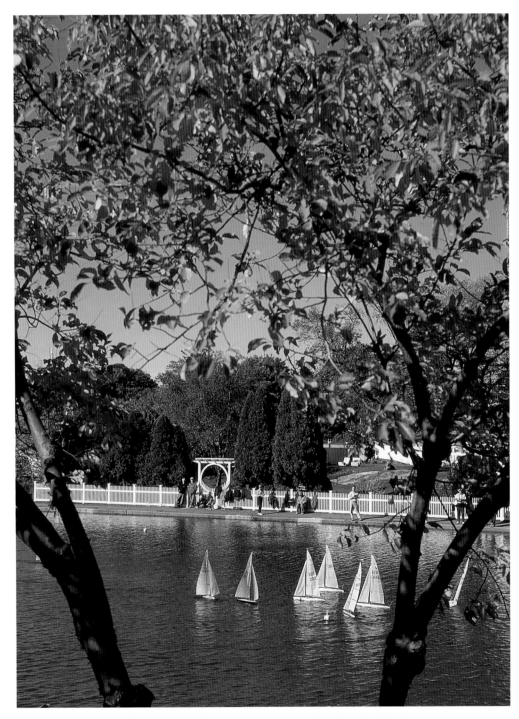

Remote-controlled miniature yachts skim along Redd's Pond.

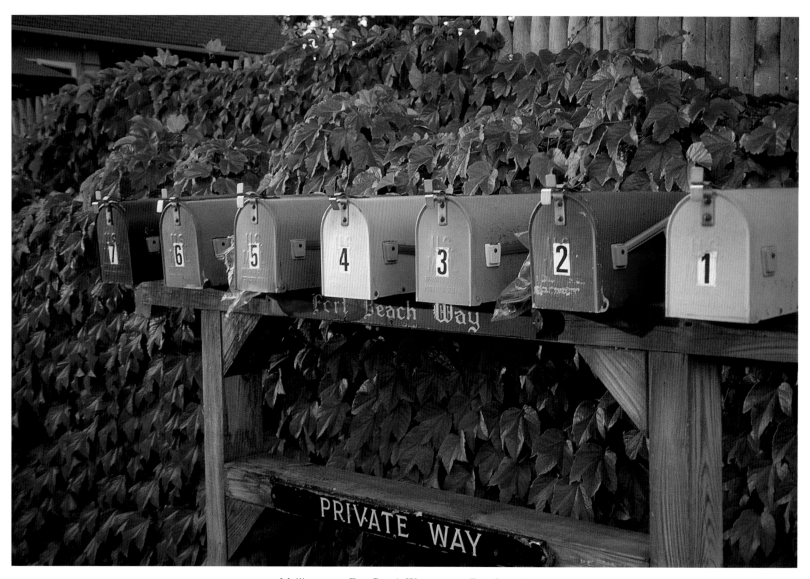

Mailboxes on Fort Beach Way, next to Fort Sewall.

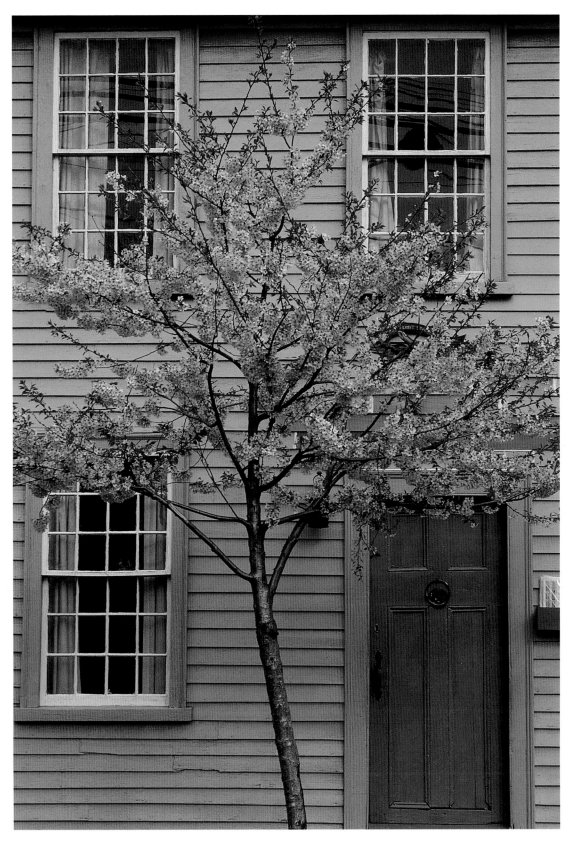

Spring blossoms on Elm Street.

Not far away we see the port,

The strange, old-fashioned town,

The lighthouse, the deserted fort,

The wooden houses, quaint and brown.

— Henry Wadsworth Longfellow,
1846

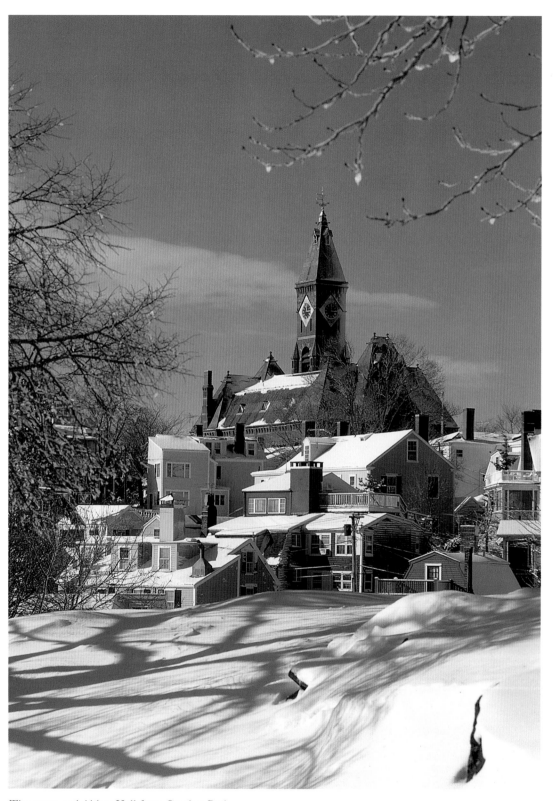

The town and Abbot Hall from Crocker Park.

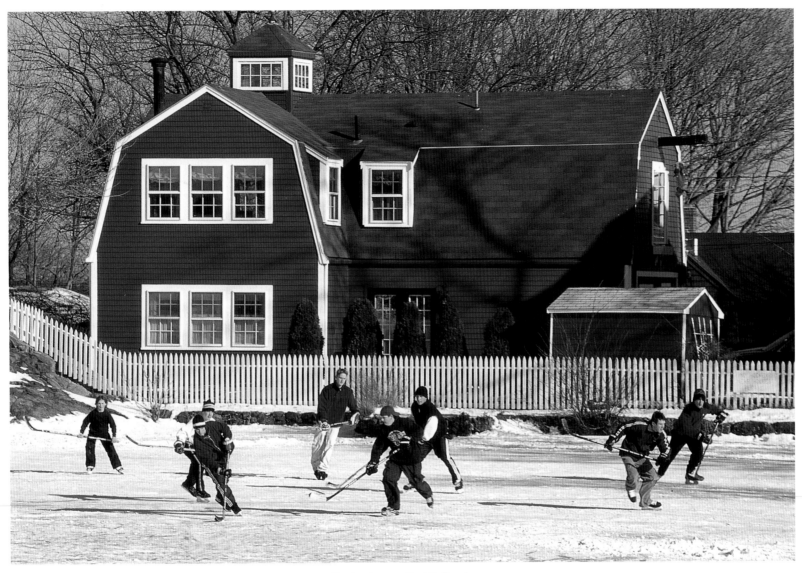

Ice hockey on Redd's Pond.

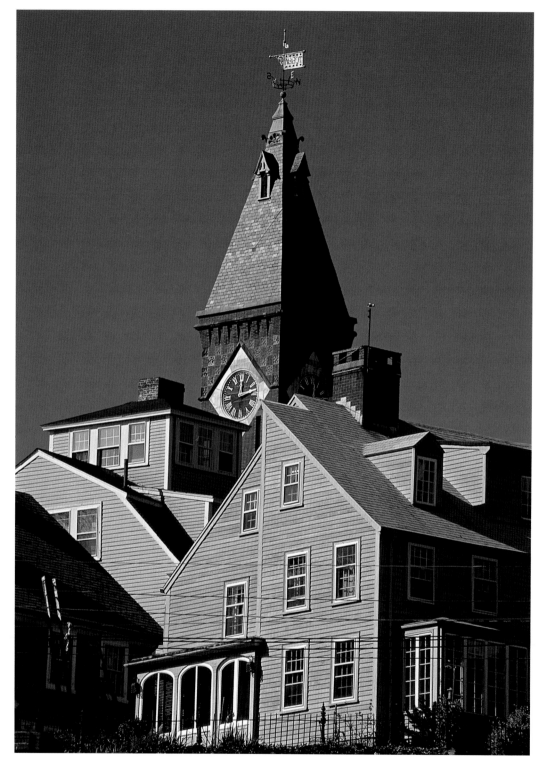

Abbot Hall nestles comfortably among its
eighteenth-century neighbors.

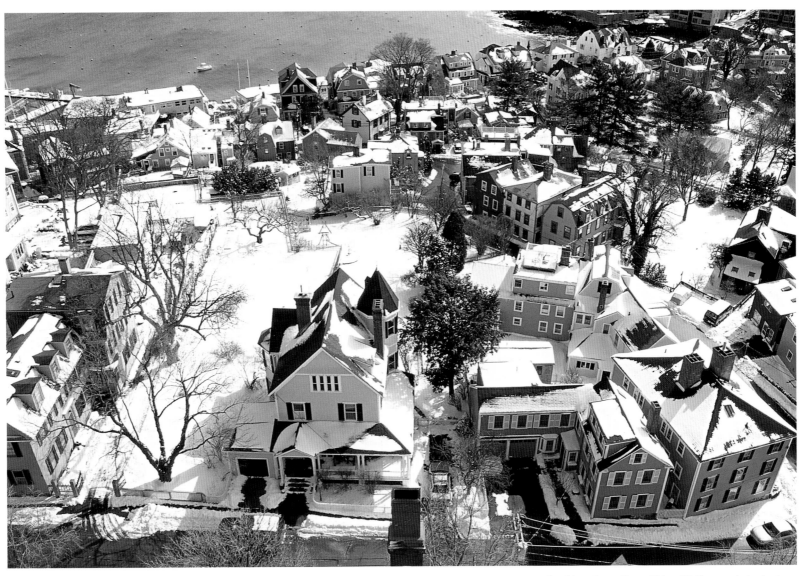

Looking down from Abbot Hall toward the harbor.

*We sauntered about this unique Village for a while, viewing
the Harbour and aridity of the rock prospect around us and
indeed beneath us for about an hour. All here indicated
strongly the fact that all Marbleheaders have to depend on the
products of the sea for their livelyhood, and I was glad after
all that I had seen the place.*

— John James Audubon, 1840

A welcoming gate on
Lee Street.

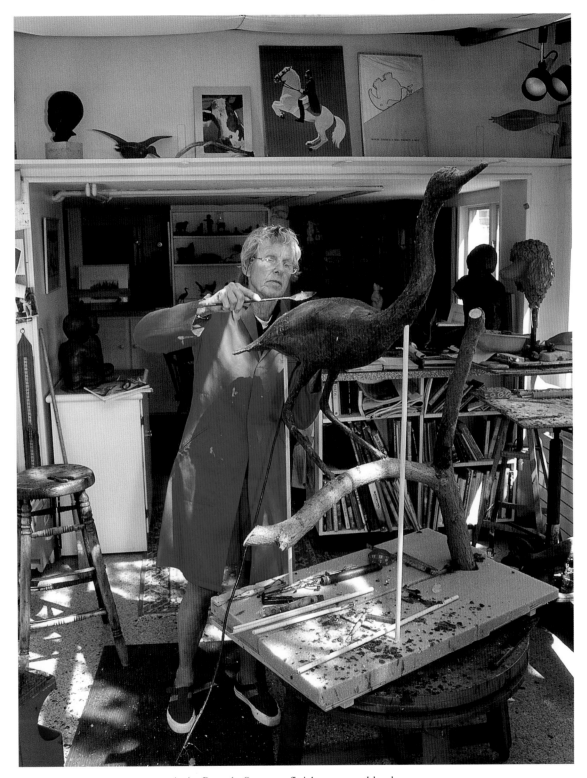

Artist Beverly Seamans finishes a great blue heron.

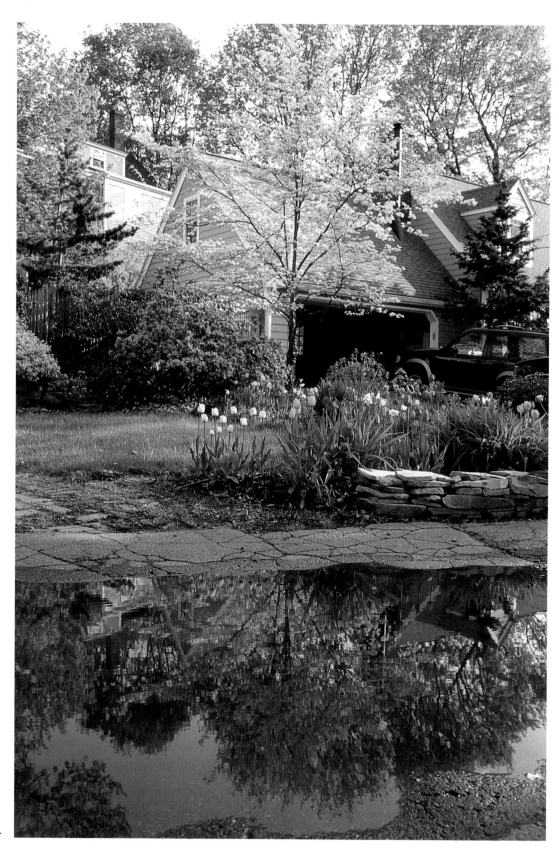

Spring reflections.

Flowers in bloom on State Street.

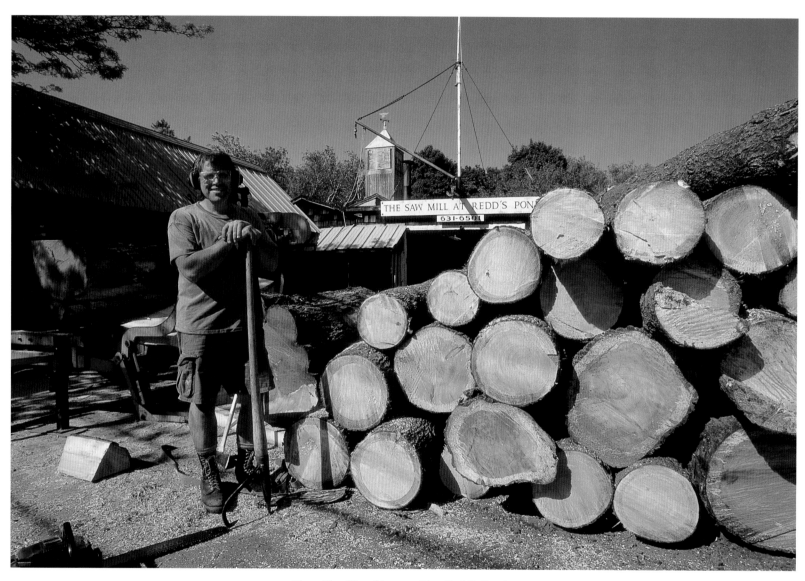

Tony Chaplik at his sawmill at Redd's Pond.

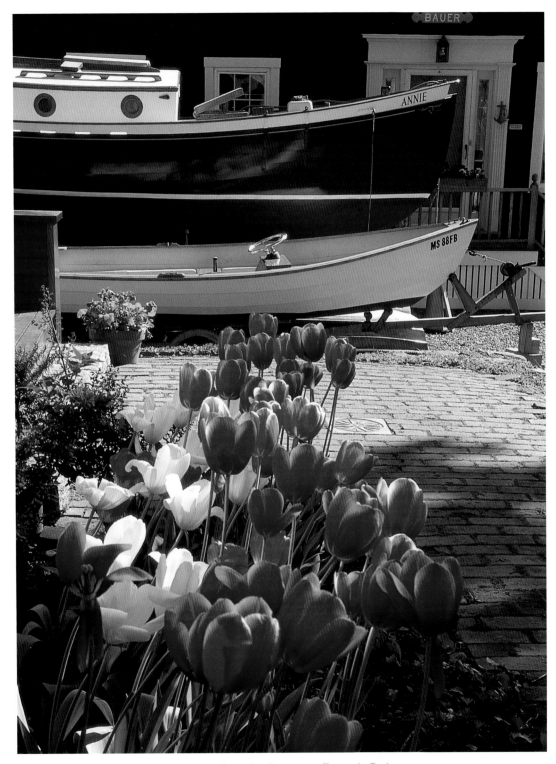

Tulips and wooden boats near Fountain Park.

Norman Street.

Long-time Marbleheader Floyd Soule.

Bill Hawkes in his "bunker," as he calls his workshop.
He recycles the brass from propeller shafts to craft
1812-style naval cannons.

A view of Crowninshield Island from off Orne Street.

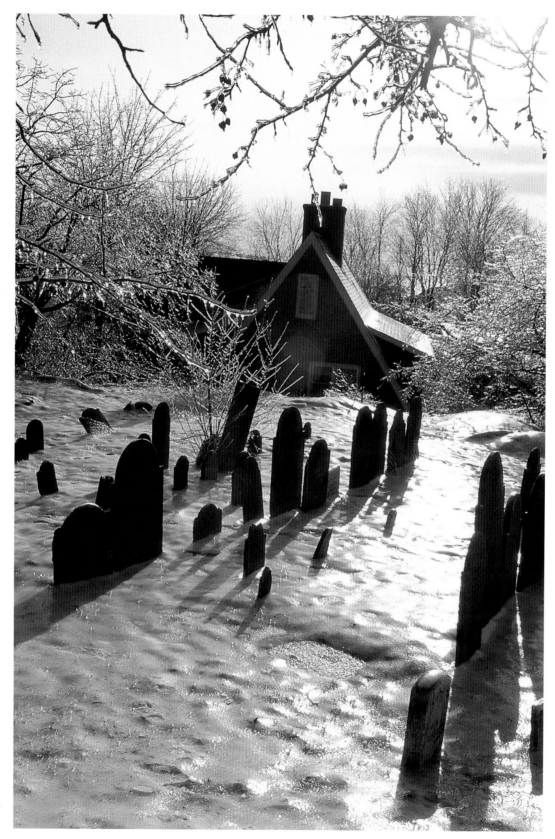

Ice glazes
Old Burial Hill.

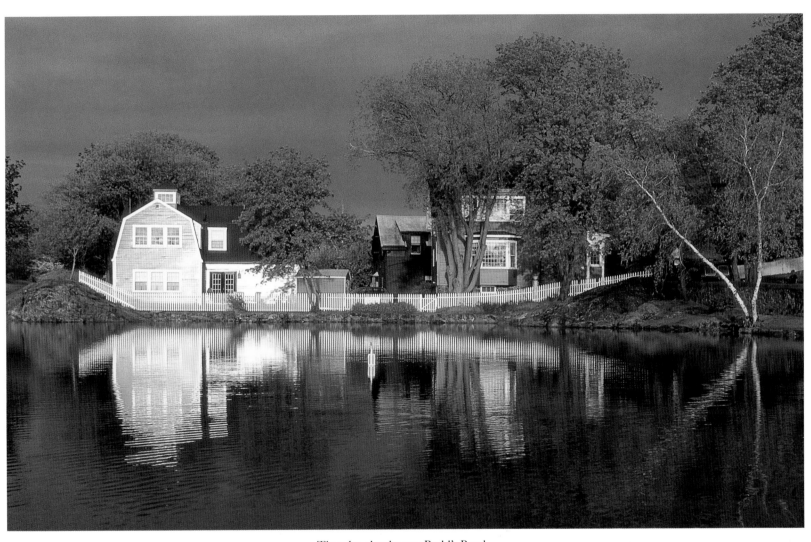

Thunder clouds over Redd's Pond.

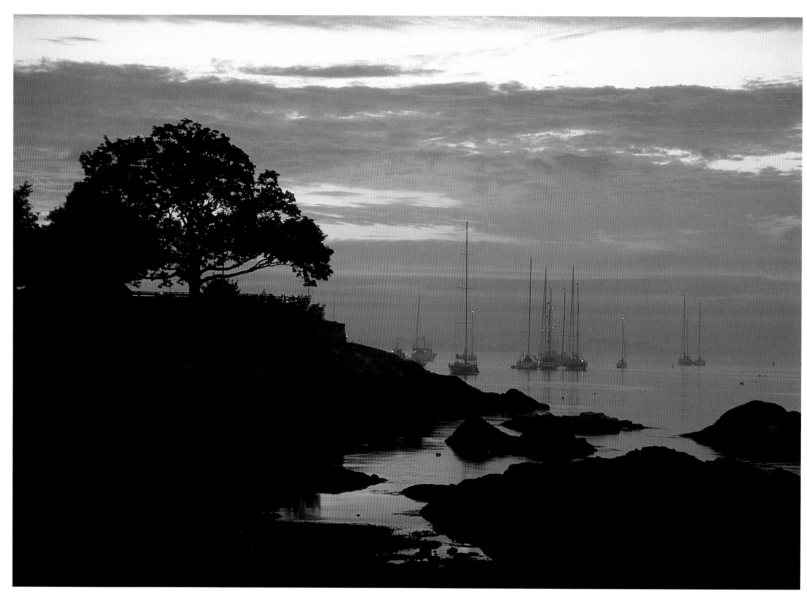

Dawn over Fort Sewall.

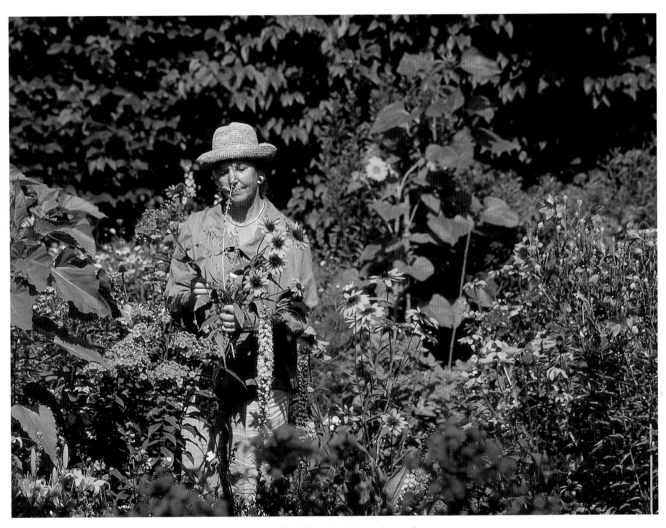

Environmentalist Gitta Amsler gathers a bouquet
from her organic garden.

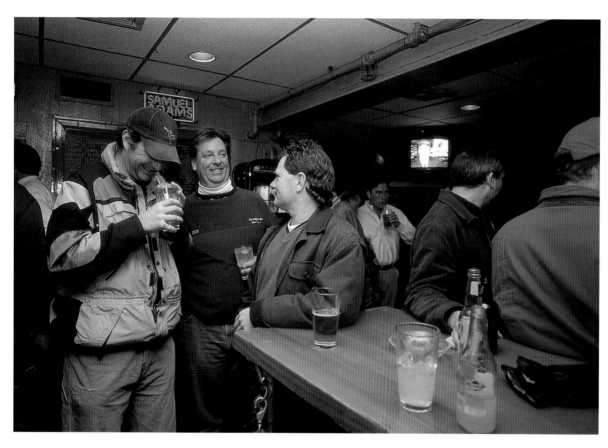

Patrons at "Maddie's" Sail Loft, a Marblehead landmark that opened its doors on Valentine's Day 1946.

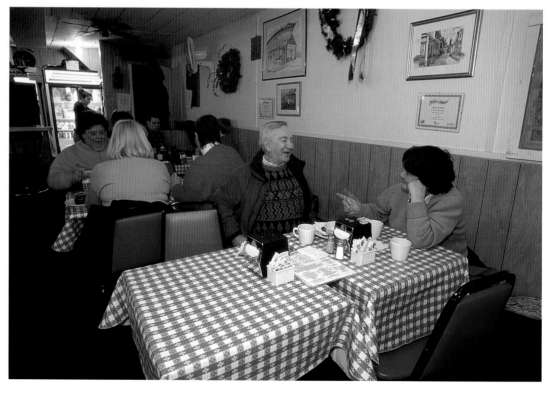

Breakfast regulars at the Driftwood.

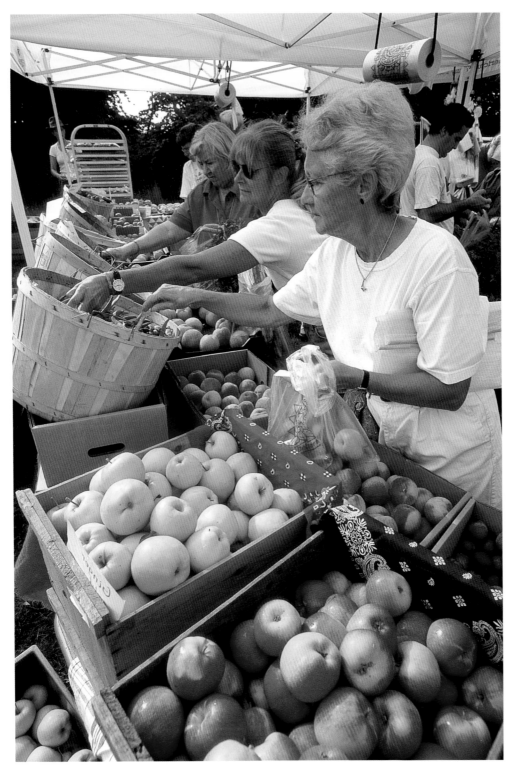

Farmer's Market is open every Saturday
during harvest season.

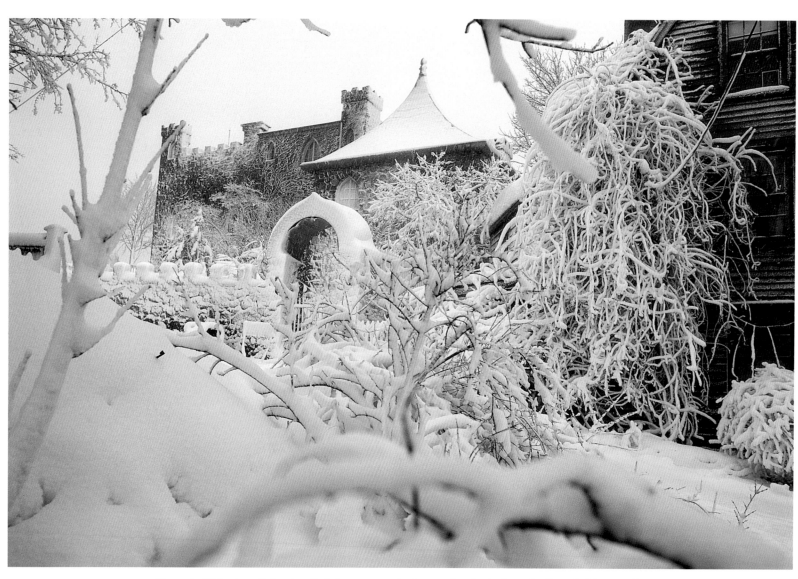

Herreshoff Castle at 2 Crocker Park Lane, once the home of yacht designer L. Francis Herreshoff,
now offers bed and breakfast in its carriage house. Built of stone in 1926, it was named
Castle Brattahlid by its original owners, Mr. and Mrs. Waldo Ballard.

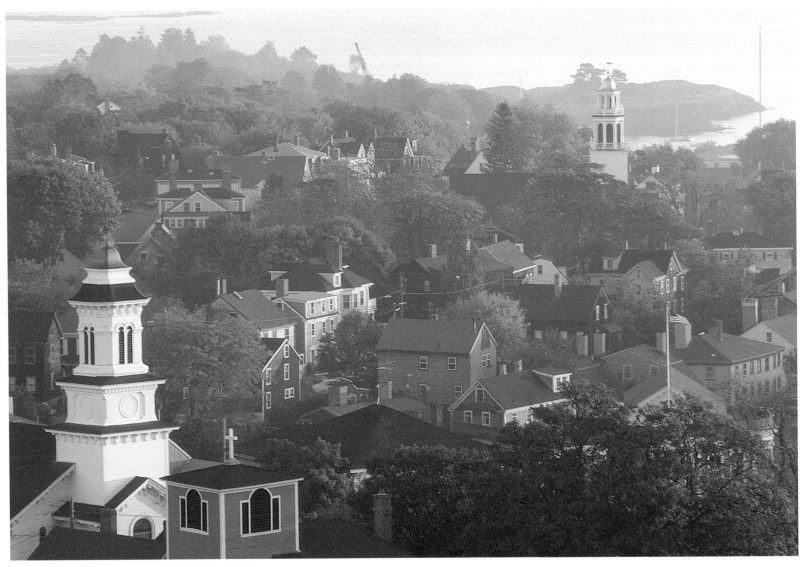

Autumn view of St. Michael's Episcopal, First Baptist,
and Old North churches from Abbot Hall.

[The town has] the feeling of antiquity.

— President George Washington, 1789

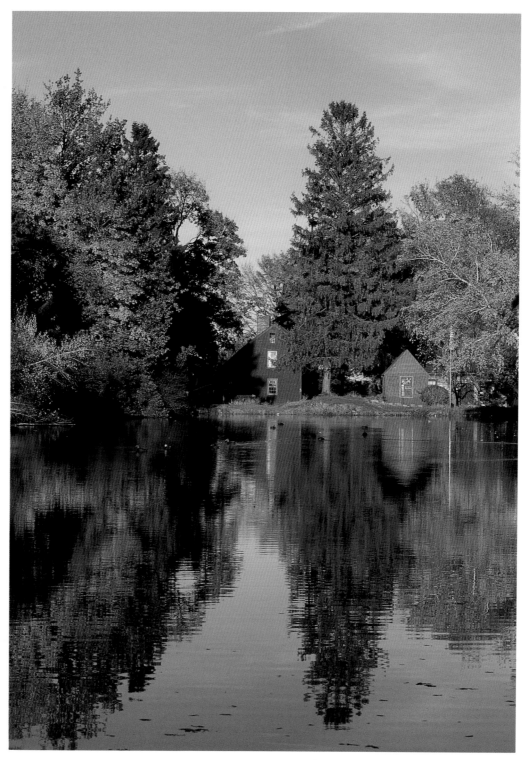

This building on Black Joe's Pond was built in 1690. "Black Joe" Brown bought half of it in 1796 and the other half in 1798. The son of a Native American and an African American, he ran a popular tavern here, playing the fiddle while his wife, "Aunt Crese," delighted children with her ginger cookies, known as Joe Froggers.

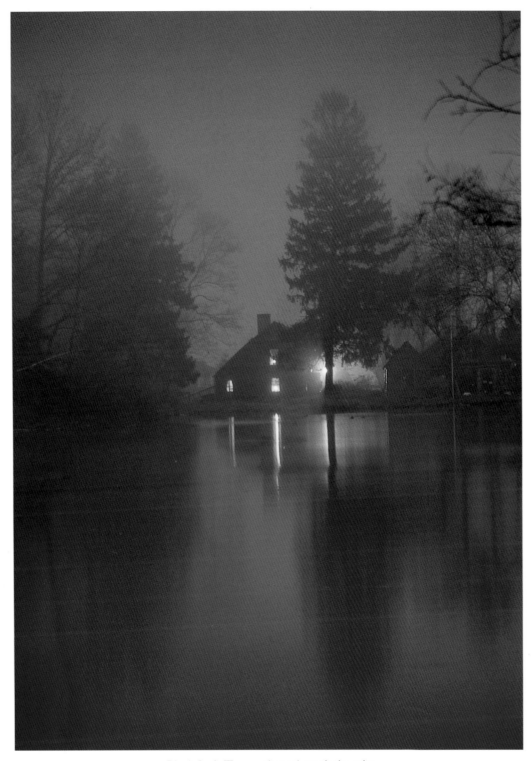

Black Joe's Tavern glows through the mist.

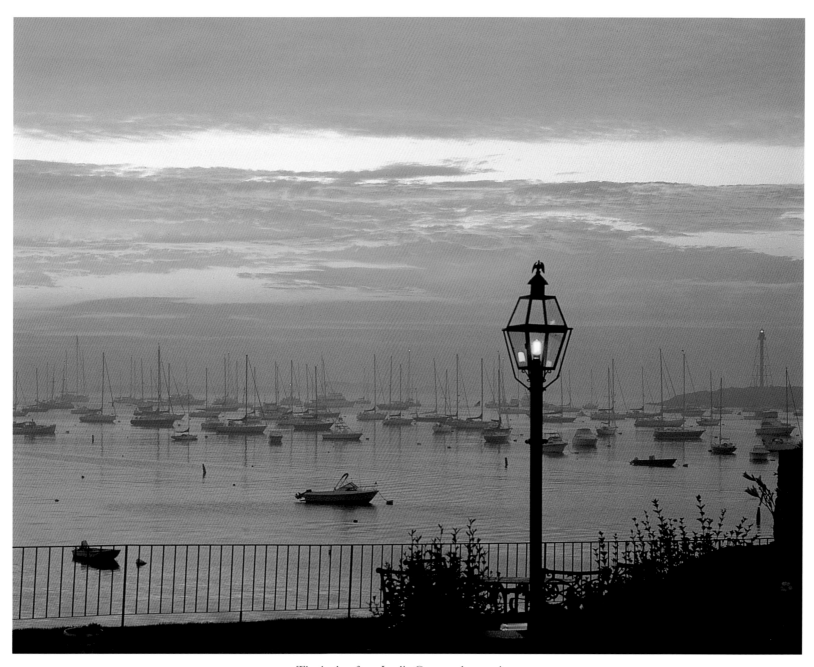

The harbor from Leslie Cove, early morning.

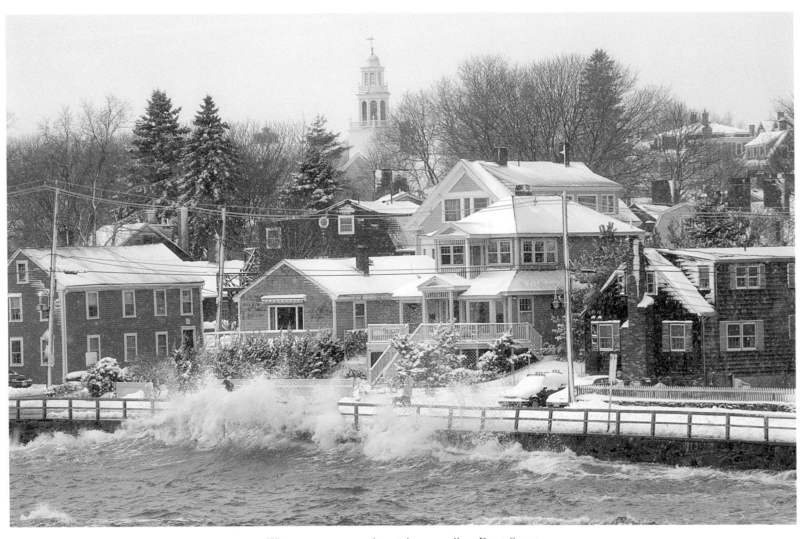

Winter storm waves slap at the sea wall on Front Street.

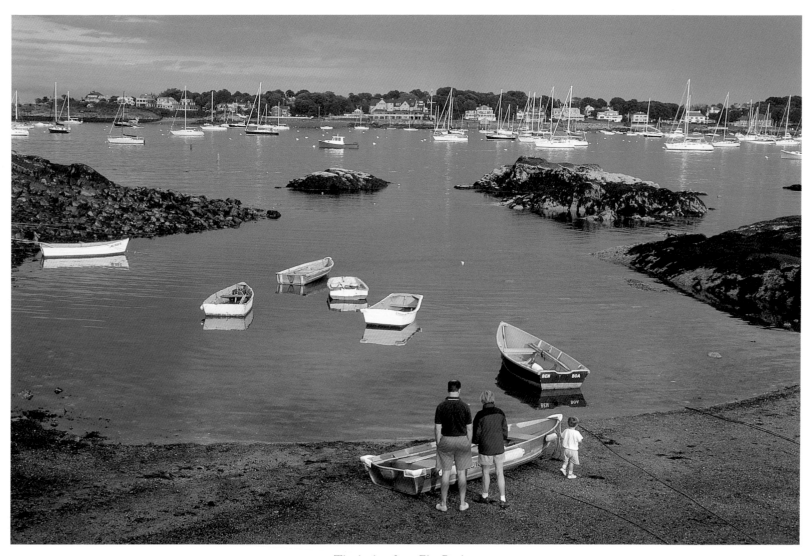

The harbor from Flat Rocks.

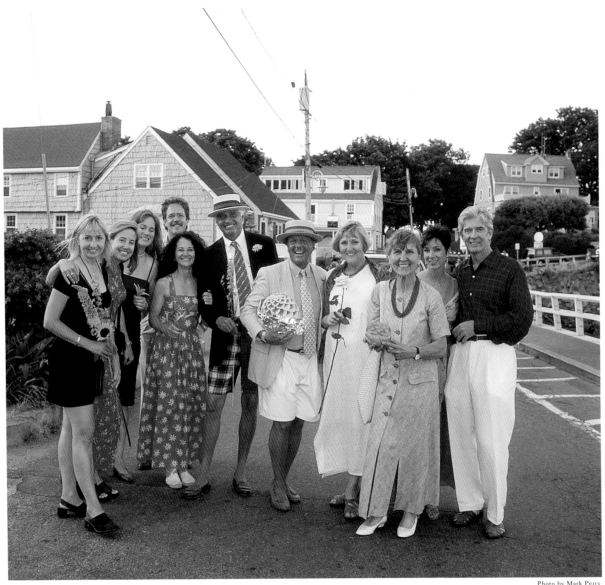

Friends near Fort Sewall.

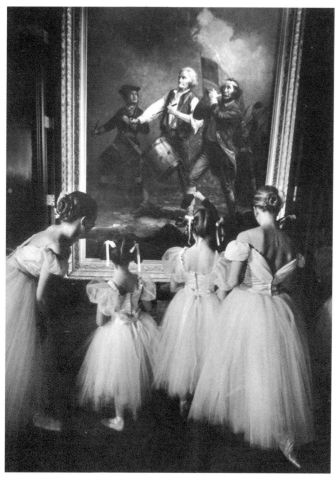

One of my favorite
black-and-whites.

Over the course of more than thirty years, my connection with Marblehead has
deepened immensely. Although my native land is Germany, Marblehead has long since
become my home. It challenges my artistic abilities, while never ceasing to satisfy my
soul. I have spent countless days walking and cycling through the narrow streets of this
charming and salty old town—always hoping for interesting light, while watching and
waiting as everyday life unfolds.

With one town having so much to offer, selecting the images in this book proved to be
a difficult task. I wish to extend my deep appreciation to all who have helped make
this book possible—especially my publisher, Webster Bull, for his sustained faith in my
vision and work, and my ever-supportive assistant, Lisa Cancelli-Willett. Also, thanks
to Jill Feron for her contributions with the design and layout. And last but certainly not
least, many thanks to my fellow townspeople for your patience as, time and time again,
I trailed in your footsteps and spied on your outings. You have graciously opened your
doors to me, led the way to your rooftops for a better angle, and shared with me your
love for Marblehead.

— Uli Welsch
Spring 2000